THE CURRIER GALLERY OF ART

HANDBOOK OF THE COLLECTION

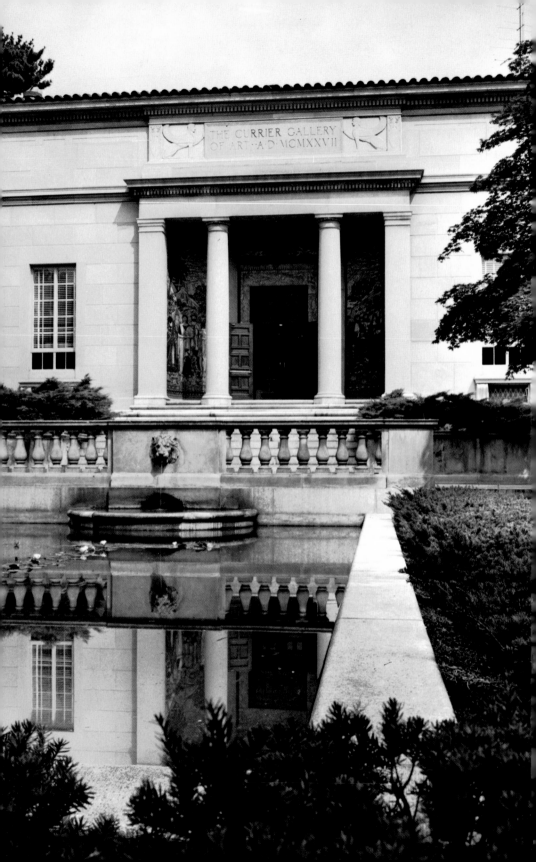

The Currier Gallery of Art

Handbook of the Collection

Edited by Michael K. Komanecky

Foreword by Marilyn Friedman Hoffman

Introduction by Robert M. Doty

MANCHESTER, NEW HAMPSHIRE

1990

Published on the occasion of
the Sixtieth Anniversary of The Currier Gallery of Art

Library of Congress catalogue card number 90–080142
ISBN 0–929710–03–7

Designed by Howard I. Gralla
Typeset in Monotype Walbaum by Michael & Winifred Bixler
Printed by Rembrandt Printing; Color Plates by Eastern Press
Photographs for this publication were made by Bill Finney,
Frank Kelley, Bob Raiche and Eric Sanford

Cover:
ALBERT BIERSTADT (1830–1902)
Moat Mountain, Intervale, New Hampshire, c. 1862
Oil on canvas, 19⅛ x 25⅞ (48.6 x 65.7)
Currier Funds 1947.3

Frontispiece:
EDWARD L. TILTON, TILTON AND GITHENS
The Currier Gallery of Art, South Entrance, 1929
National Register of Historic Places, 1979

Contents

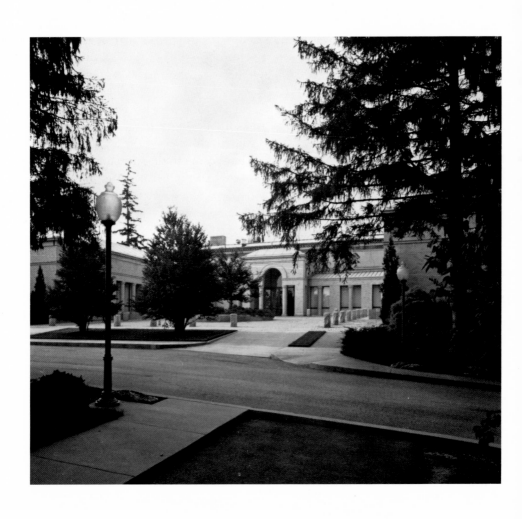

HARDY HOLZMAN PFEIFFER ASSOCIATES, ARCHITECTS
The Currier Gallery of Art, North Entrance, 1982

Foreword

WE present with pleasure the second edition of The Currier Gallery of Art *Handbook*. The Currier's first *Handbook*, published in 1979, heralded to art lovers and experts in New Hampshire and around the world the consistently high quality of our collection. During the last ten years, under the directorship of Robert M. Doty, the Currier Gallery continued to acquire significant works of art, complementing all areas of its diverse holdings. In addition, the building was substantially expanded during his tenure.

By far the most important acquisition to have come to the museum since 1979 is the Isadore J. and Lucille Zimmerman House. In 1950 Dr. and Mrs. Zimmerman commissioned Frank Lloyd Wright to design a house and furnishings for them. The commission resulted in a small but distinctive Usonian house, complete with furniture, textiles and gardens designed by the architect. The Currier is now preparing to open the house to the public, in conjunction with the Zimmermans' wishes. Like other parts of the collection, the Zimmerman House will be the subject of a future scholarly publication.

We have previously published substantial portions of the Currier's collections. The most notable publications are *The Murray Collection of Glass* (1985); "Master Prints from the Collection," *Bulletin* (Spring 1985); and "The Vincent and Edith Vallarino Collection of Photography," *Bulletin* (Spring 1986). Our acquisitions have also been listed in the *Annual Report* which, along with the *Bulletin*, has been published continuously since 1929.

The publication of this *Handbook* has required the efforts of many people: the book was edited by curator Michael K. Komanecky, with special assistance from assistant curator Inez McDermott. We thank former director Robert M. Doty for his introduction. Maria Graubart, Kathy Jean, Timothy Johnson, Barbara Myers, Amanda Preston, David D. J. Rau, Julie Solz, Catherine Wright, volunteer Hannah Perutz, and photographer Bill Finney each contributed to this project. I also wish to thank the board of trustees for its assistance in raising funds and for its unflagging interest in and support of this project.

Finally, we are most grateful to the foundations and individuals whose financial support has made this publication possible. We especially acknowledge the N. S. and E. N. Bean Foundation, The Samuel P. Hunt Foundation, The Ann deNicola Trust, Amoskeag Bank and James S. Yakovakis, Trustees, The Agnes M. Lindsay Trust, and The Gilbert Verney Foundation for their generous contributions. We also acknowledge the late Mrs. Henry (Olga M.) Wheeler, Jr. for her many generous gifts to the museum's Henry and Olga Wheeler Fund, from which we have drawn for this project.

Marilyn Friedman Hoffman
DIRECTOR

Editor's Note

THIS second edition of The Currier Gallery of Art *Handbook* is a testament to the continuing qualitative growth of the permanent collection. The commitment of the Currier to acquiring single, significant examples of Western art is evident when one reviews the purchases, gifts, and bequests of the last ten years. The museum's success, however, necessitated for the purposes of this book difficult decisions as to which new acquisitions to include. In addition, due to limitations of space, some objects illustrated in the 1979 *Handbook* were eliminated from the present volume. We hope that comparison of the two editions will reveal a balance that fairly represents the highlights of the museum's collecting activities over its first sixty years.

There have also been changes in the organization of the book, primarily to arrange it in more distinct sections according to object types and geographical origins. An index of artists and makers has also been added for the reader's convenience. Dimensions are given in inches (centimeters in parentheses); height precedes width precedes depth. Any variations from this norm are noted. For silver and pewter, all visible marks and inscriptions are included.

I thank Howard I. Gralla, whose talents as a graphic designer are everywhere visible in this book. It has been my pleasure to work with Howard on a number of projects over the years, and the process and results have been tremendously rewarding.

Michael K. Komanecky
CURATOR

Introduction

MOODY CURRIER was the very model of a successful American in the nineteenth century. Born in Boscawen, New Hampshire, on April 22, 1806, his boyhood was spent on a farm. He studied at Hopkinton Academy and Dartmouth College, from which he graduated with honors in 1834. He returned to Hopkinton Academy as principal but soon accepted a new post as principal of the high school in Lowell, Massachusetts. He also began to study law and, having gained admission to the bar, he opened an office in Manchester in 1841. At the same time he became proprietor and editor of the Manchester *Democrat*.

Moody Currier had come to Manchester just as the city entered a period of expansion in population and industry. The water power of the Merrimack River had been used for the manufacture of textiles since the late eighteenth century. With the incorporation of the Amoskeag Manufacturing Company in 1831, one of the major industries in the United States began a century of growth and prosperity. Moody Currier took a leading position in the new commerce. A founder and cashier of the Amoskeag Bank, he became president when it was re-organized as the Amoskeag National Bank & Trust Company, a position he held until 1892. He was also the first treasurer and later president of the Amoskeag Savings Bank and a founder and director of the People's Savings Bank. He held advisory positions in three railroad companies and several firms in Manchester. At the same time, he was active in politics, serving as clerk of the New Hampshire Senate in 1843–44, as Senator in 1856, and later as president of the Senate. He sat on the Governor's Council in 1860–61, and was elected Governor in 1884.

Along with these activities, Moody Currier found time to pursue other interests. He was a trustee of the Manchester Institute of Arts and Sciences, the City Library, and president of the Manchester Art Association. A contemporary biographer asserts that he was proficient in philosophy, astronomy, geology, botany, natural history, mathematics and theology. He was an accomplished poet whose verse was published.

Before his death in 1898, Currier laid plans to have his estate become a gallery of art for the people of New Hampshire. His intentions were honored by his third wife, Hannah Slade Currier, who died in 1915. Under her will, the Hillsborough County Probate Court appointed the board of trustees in 1917 and directed them to begin the task of building an art gallery to be erected on the site of the Currier mansion in Manchester. It was not a simple matter. Proposals by Ralph Adams Cram and R. Clifton Sturgis were reviewed and rejected before the board accepted a design by Edward L. Tilton, who was associated with Alfred M. Githens in New York. The newly erected Currier Gallery of Art was opened to the public on October 9, 1929.

Despite their interest in supporting the arts, Governor and Mrs. Currier did not collect art. When the museum opened, the permanent collection consisted

solely of paintings in oil and watercolor assembled and bequeathed to the Currier Gallery by George A. Leighton, a Manchester industrialist who had moved late in life to Los Angeles, California. His choices were devoted to landscape and genre paintings. Prior to opening, Miss Penelope Snow, a trustee and niece of Mrs. Currier, had donated scenic wallpaper panels by the nineteenth century French artist Felix Sauvenet. A panoramic view of the city of Lyons, France, the panels were brought to America by Captain George Lunt as a present for Abijah Howard who married into the Vaughn family of Thetford, Vermont. They remained on the walls of the Vaughn house for almost a century.

Because the permanent collection was so small, loan exhibitions were used extensively from the start. From the first exhibition, borrowed from Grand Central Art Galleries in New York, the trustees purchased a bronze sculpture by Harriet Frishmuth, entitled *The Crest of the Wave*, which was installed in a fountain adjacent to the main entrance. The acquisition was the result of a plan to "gradually assemble, through careful selection, a collection of paintings, bronzes, and decorative arts, that shall be worthy of the generous gift of ex-Governor and Mrs. Currier, and have a far-reaching influence on the lives of those who use the museum collections." It is significant that from the beginning, the board of trustees and staff regarded the acquisition process as one of "careful selection." As a result, the collection grew slowly, but with distinction.

During the nineteen-thirties, the first director, Maud Briggs Knowlton, steadfastly adhered to the policy that quality was preferable to quantity. The museum purchased the portrait of *John Clerk of Eldin* by Sir Henry Raeburn in 1933, and the portrait of *John Greene* by John Singleton Copley in 1935. A gallery was set aside for the continuous exhibition of the decorative arts and several pieces of pewter were acquired in 1931. The following year the collection of American decorative arts was firmly established by the purchase of an important collection of eighteenth century furniture, rugs, and utensils formed by Mrs. DeWitt C. Howe, a pioneer collector of New England art and artifacts. This bold maneuver was followed in 1937 by the equally enterprising purchase of a major fifteenth century tapestry made in Tournai, France, from the collection of Mrs. Genevieve Garvan Brady. The feat of acquiring such a masterpiece of French art for a small museum prompted the *Manchester Union-Leader* to state: "This addition to the treasures of our local gallery should bring increased attention to it. There is no more lovely or instructive spot to visit in all New Hampshire. The Gallery's grounds are always beautiful. The structure itself is an architectural joy, inside and out. Its permanent exhibits include worthwhile examples of all the fine arts, not the least of which is the display of early Americana. Its loan exhibits are as varied as they are interesting. And this program is rounded out in season by lectures and motion picture displays." Attention did come, often in the form of gifts. In 1942 Richard J. Healey donated his collection of glass which included some four thousand pieces, and in 1944 Orien B. Dodge gave a comprehensive collection of late nineteenth-century posters, with later additions by Mr. and Mrs. Robert Davison in memory of Alonzo Elliott.

In 1946 Gordon M. Smith was appointed director. An art historian, he was especially sensitive to exhibiting the collection in a manner which enhanced the objects and revealed their significant characteristics. He not only approved of the selective manner which had been applied to the formation of the collection, but also moved toward a new definition of the policy. Writing in the January 1952 issue of *Art News*, Smith stated: "The Currier Gallery of Art . . . has formed an acquisition policy . . . based on the idea that one masterpiece is more to be desired than a roomful of run-of-the-mill paintings, that a few good paintings can do more to stimulate in the general public an interest in art than can any number of study pieces Our long-range objective is a necessarily small, but very choice collection of top-quality paintings, each making a distinct contribution toward an appreciation and understanding of the major movements and periods in history." He had practiced this theory by purchasing *Portrait of a Lady* by Lorenzo Costa in 1947, and *The Seine at Bougival* by Claude Monet in 1949. In 1948 he commissioned Charles Sheeler to visit Manchester and create images based on the nineteenth century textile mills. He continued to acquire significant paintings: *Dedham Lock and Mill* by John Constable in 1949, and *Spindrift* by Andrew Wyeth in 1950. The combination of Gordon Smith's devotion to the best in art, and his intention to bring The Currier Gallery of Art into the front ranks of American museums, consolidated the gains of the past and set guidelines for the future.

Many factors determine the growth of an art museum and its collections. The endowment fund was created from the original bequest of Governor and Mrs. Currier. In addition, purchase funds were given by Mabel Putney Folsom, Ralph W. Fracker, Richard J. Healey, George A. Leighton, and Dr. and Mrs. Isadore J. Zimmerman. In 1958 the director, Charles E. Buckley, and the president of the board of trustees, Judge Peter Woodbury, organized the Friends of The Currier Gallery of Art, whose members regularly contribute to a purchase fund for works of art. Membership has grown steadily, and the more than 100 works acquired with the Friends fund include works by Thomas Cole, Alexander Calder, Adolph Gottlieb, Edward Hopper, Jasper Johns, Jules Olitski, Edward Steichen, and Neil Welliver. Directors have brought their expertise and special interests to bear on selectively expanding the collection and seeking a balanced integration. Charles Buckley revived an active interest in acquiring decorative art, with an emphasis on New Hampshire furniture, and sought out several superb pieces for the collection. On the occasion of the museum's thirty-fifth anniversary in 1964 he purchased *Seated Nude* by Henri Matisse and *The Wounded Clown* by Georges Rouault. Before American art became celebrated, he acquired paintings by Edward Hopper, Georgia O'Keeffe, Charles Demuth, and Josef Albers. This area was further reinforced by William Hutton, who added important paintings by William Jennys and Charles Burchfield. Under David S. Brooke the representation of European paintings was strengthened through the purchase of works by Mattia Preti, Jan de Bray, Claude Joseph Vernet and Jean-Baptiste Greuze. Gifts continued to be a great resource. Henry Melville Fuller helped to supplement the

holdings in American art through gifts of paintings by Charles Caleb Ward, Lilly Martin Spencer, Frederic Edwin Church, William Holbrook Beard, Severin Roesen and Asher B. Durand. A gift of English pewter from Mr. and Mrs. Winthrop L. Carter, a bequest of American pewter from Mrs. Peter Woodbury, and a gift of English silver from Mr. and Mrs. Edward Dane were major additions in the decorative arts. Lotte Jacobi and her son John Hunter made several gifts to expand the holdings in photography, a part of the collection that was virtually created by gifts from Vincent Vallarino and his mother Edith Vallarino.

The Currier Gallery of Art has been especially fortunate in receiving several major collections of glass. The collection of Richard J. Healey, mentioned previously, was notable for pressed pieces from New England and the Midwest. Mr. and Mrs. Curtis H. Caldwell presented 51 pieces of silvered glass and flasks from Keene, New Hampshire. Mrs. James O. Moore gave 107 pieces made by the Bryce firm in Pittsburgh. In 1974 Albert C. Murray donated a magnificent collection formed by his wife Sophie. More than 575 pieces, it provided the museum with an important representation of works by English cameo artists and American art nouveau artists Joseph Locke, Louis Comfort Tiffany, Frederick Carder and others. Through these, and gifts by Frank G. Hale, Mrs. Charles H. Greenleaf, Francis Sanborn, Sherburne Cutter, and Elisha and Doris Camp, the collection now presents a broad survey of glassmaking in America encompassing about 5,000 pieces.

The history of the Currier would not be complete without mention of its first curator, Melvin Edwin Watts. Originally appointed registrar in 1938, he was made curator in 1946 and served in that position for 35 years. An expert in American decorative arts, especially furniture and glass, he made valuable contributions to the museum through his exhibitions, writings, and lectures.

In his reports for the years 1975 and 1976, David Brooke noted that, as a vital and growing institution, the museum faced acute shortages of exhibition, work, and storage space. In 1977 Robert M. Doty was appointed director and continued to address these problems. During 1978 feasibility studies were made on the museum's role in the community and the prospects of raising funds. In December the board of trustees decided to start a search for the architect who would design an addition to the building. During the process of selection several factors began to emerge: the character and values of the existing structure had to be preserved, the grounds and facade of the building to the south had to remain intact, and the need for new space as well as removal of barriers for the handicapped had to be met. By July, 1979, Hardy Holzman Pfeiffer Associates of New York, with Hugh Hardy in charge, had been designated as architects.

On December 6, 1979, Kimon S. Zachos, president of the board of trustees, presided at the inauguration of the Fiftieth Anniversary Building Fund. Under his direction, the fund would reach and surpass the goal of $2,500,000. The largest single gift was a Challenge Grant from the National Endowment for the Arts, but it was the combined generosity of many individuals, foundations, and corporations that made the fund drive successful. Meanwhile, the Board of Mayor and

Aldermen gave permission to close Myrtle Street between Beech and Ash Streets, the architects produced their plans, and construction officially started on September 4, 1980. Despite moving the collections and staff into temporary quarters, all programs and activities continued without interruption. Construction also moved forward steadily and dedication of the new building was held on the weekend of April 2, 1982. The completion of the addition to the original building transformed an elegant but crowded and outmoded facility into a gracious, comfortable and efficient museum. The building created by Hardy Holzman Pfeiffer Associates has admirably met the goal of integrating heritage with contemporary requirements and retaining classical harmony while providing the capability for a greater range of functions.

As the new building went up, plans were being made to renovate the old. With a grant from the National Endowment for the Arts, gifts from many generous donors, and planning by BCM Architects, floors were refinished, walls recovered, skylights cleaned, new lighting installed, all followed by the first comprehensive reinstallation of the galleries in more than thirty years. As a result, the whole complex was unified as the old galleries were brought into a more cohesive relationship with the new.

Enlarging and maintaining the physical facility is only part of museum operations. Acquiring outstanding works of art in all media, providing proper care for the collections, creating an exhibition program appropriate to the interests of a local audience, publishing catalogues, and circulating exhibitions for a national audience are all part of the ultimate goal: reinforcing the role of the museum as a source of public recreation and education. The Currier Gallery of Art has been faithful to that goal since its inception. Less than a year after the museum opened, the board of trustees broadened the means of promoting understanding between the public and the museum through the purchase of motion picture projection equipment. In 1939, the Currier Art Center was established with the purchase of the grounds and building adjacent to the museum on the north. An active program of instruction in the creative arts was developed for children and is today a vital asset. In many ways, the museum and its programs interact with the individual to make life more complete. In keeping with the museum's mission to provide the public with access to its recreational and educational benefits, this publication brings the collection of The Currier Gallery of Art to the wider audience which it is so willing to serve.

Robert M. Doty
DIRECTOR, 1977–1987

Index of Artists and Makers

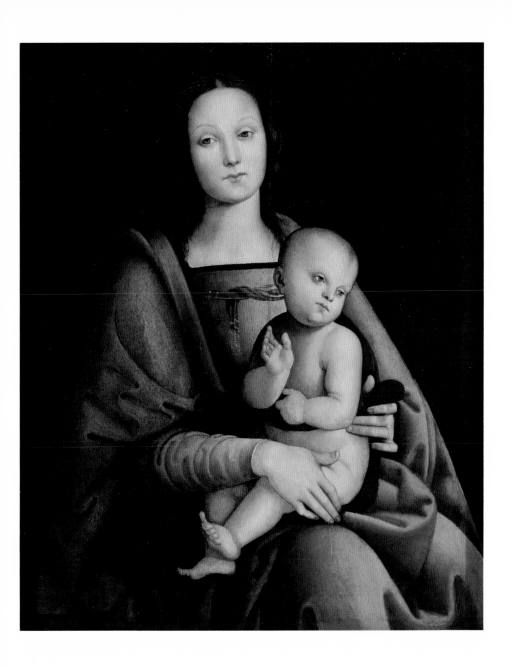

PIETRO VANUCCI called PERUGINO
(1445–1523), Italian
The Madonna and Child, c. 1495
Tempera on panel, 24 x 29½ (60.9 x 74.9)
Currier Funds 1952.2

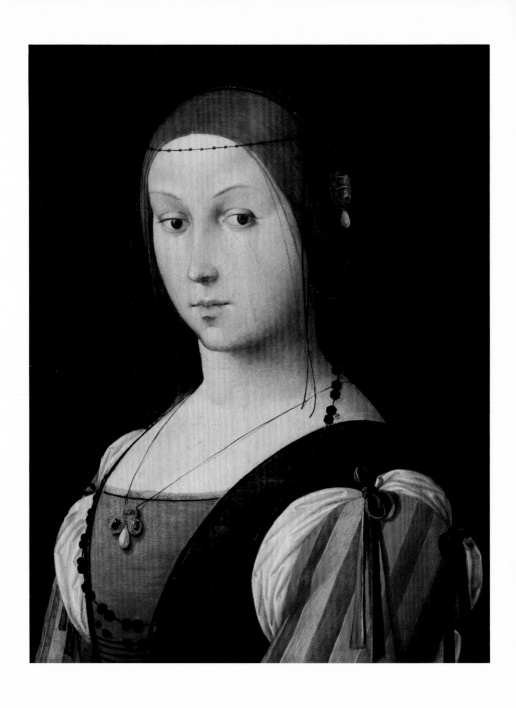

LORENZO COSTA (c. 1460–1535), Italian
Portrait of a Lady, c. 1506
Oil on canvas, transferred from panel,
17⅝ x 13⅝ (44.7 x 34.6)
Currier Funds 1947.4

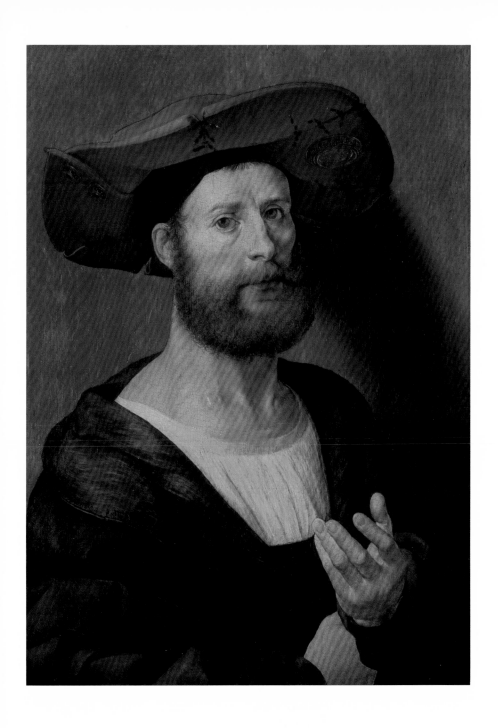

JAN GOSSAERT, called MABUSE
(c. 1470–1533), Flemish
Self-Portrait, c. 1520
Oil on panel, 17 x 12¼ (43.2 x 31.1)
Currier Funds 1951.6

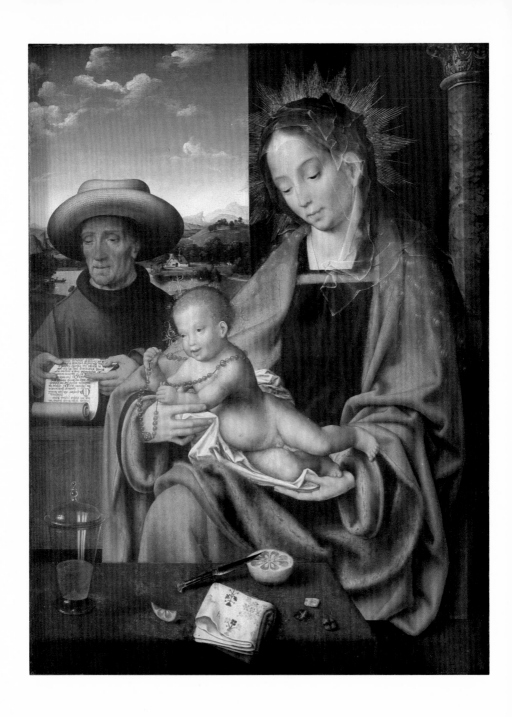

JOOS VAN CLEVE (1485–1540), Flemish
Holy Family, c. 1520–25
Tempera on panel, 29½ x 22 (74.9 x 55.9)
Currier Funds 1956.5

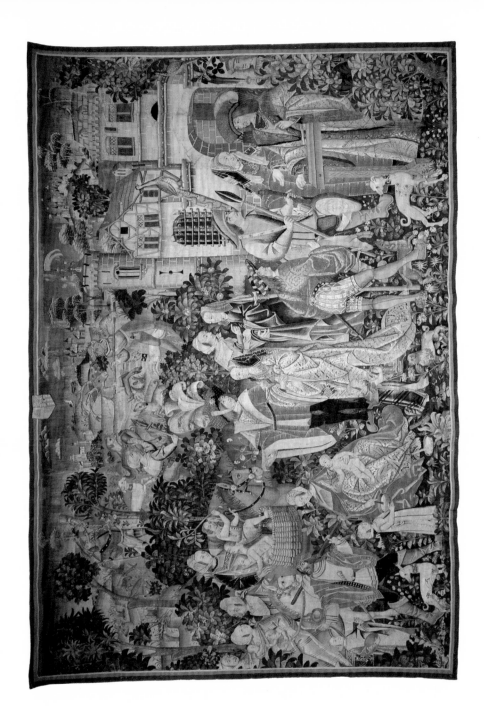

MAKER UNKNOWN, Franco-Flemish
(probably Tournai)
The Visit of the Gypsies, c. 1490
Wool tapestry, 138 x 198 (350.5 x 502.9)
Currier Funds 1937.7

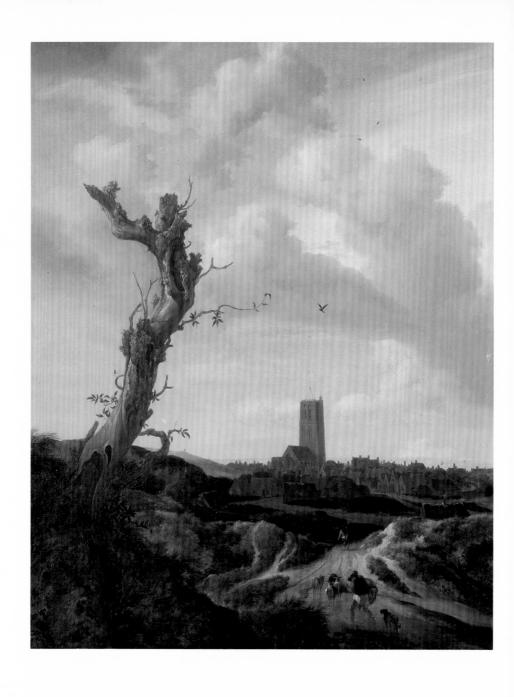

JACOB VAN RUISDAEL (1628–1682), Dutch
View of Egmond-on-the-Sea, 1648
Oil on panel, 25⅝ x 19⅝ (65.1 x 49.8)
Currier Funds 1950.4

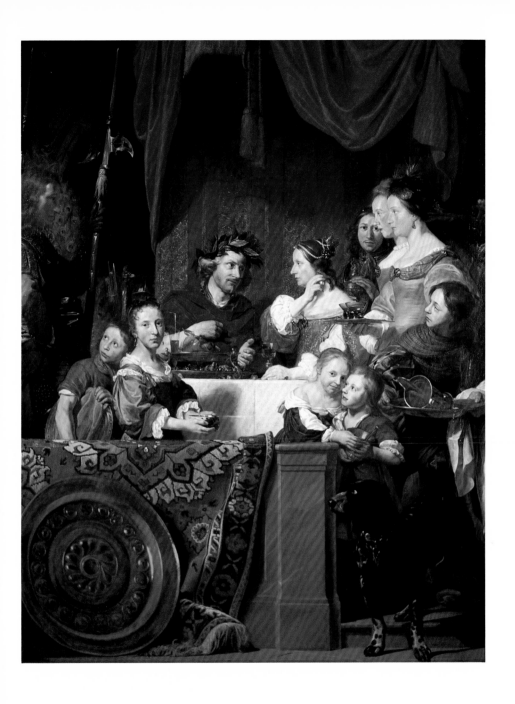

JAN DE BRAY (1627–1697), Dutch
Banquet of Anthony and Cleopatra, 1669
Oil on canvas, 98 x 75 (248.9 x 190.5)
Currier Funds 1969.8

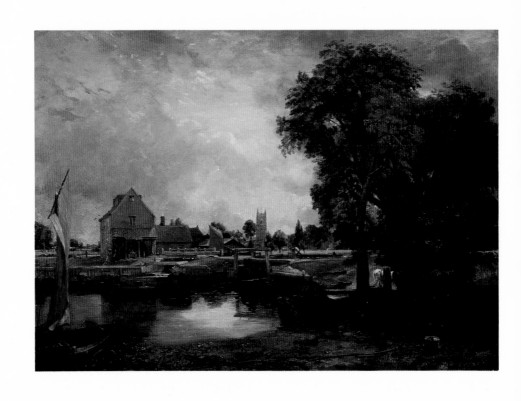

JOHN CONSTABLE (1776–1837), English
Dedham Lock and Mill, 1820
Oil on canvas, 21½ x 30½ (54.6 x 77.5)
Currier Funds 1949.8

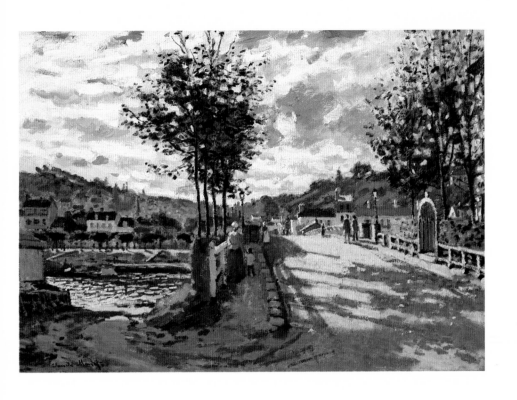

CLAUDE MONET (1840–1926), French
The Seine at Bougival, 1869
Oil on canvas, 25¾ x 36⅜ (65.4 x 92.4)
Mabel Putney Folsom Fund 1949.1

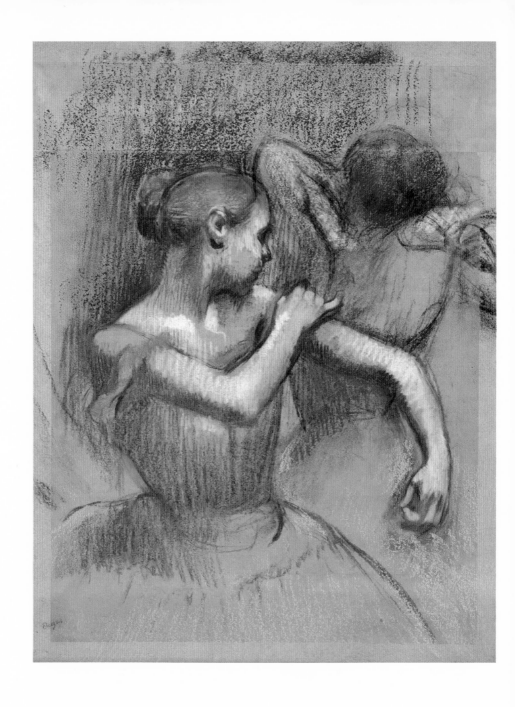

HILAIRE-GERMAIN-EDGAR DEGAS
(1834–1917), French
Dancers, c. 1890
Pastel on tan and tracing paper mounted on
grey paper, 26½ x 21 (67.3 x 53.3)
Gift of Arne Lewis and Eleanor Briggs in
memory of Mary Cabot Briggs 1973.1

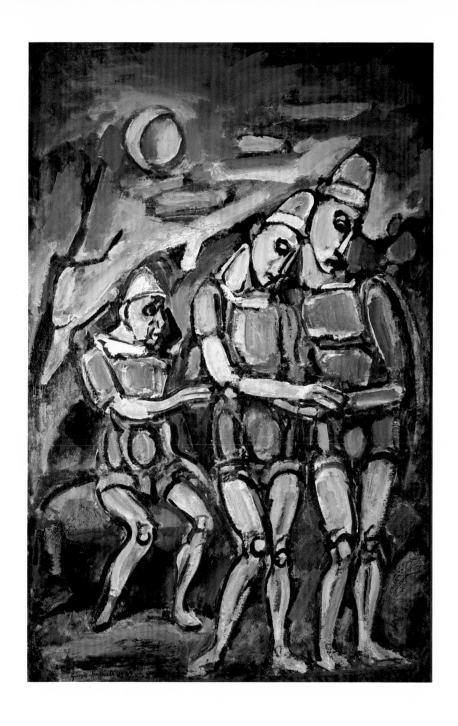

GEORGES ROUAULT (1871–1958), French
The Wounded Clown, 1939
Oil on paper, 72 x 47 (182.8 x 119.4)
Currier Funds 1964.2

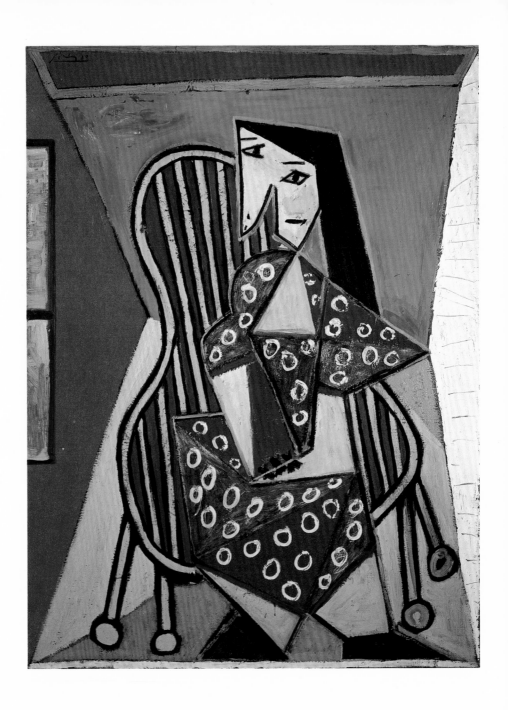

PABLO PICASSO (1881–1973), Spanish
Woman Seated in a Chair, 1941
Oil on canvas, 51 x 38 (129.6 x 96.5)
Anonymous gift 1953.3

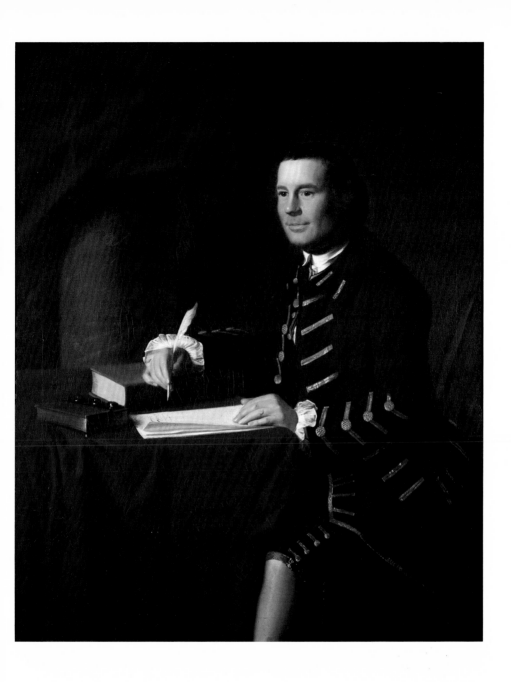

JOHN SINGLETON COPLEY (1738–1815),
American
John Greene, 1768–70
Oil on canvas, 50¼ x 40¼ (127.6 x 102.2)
Currier Funds 1935.4

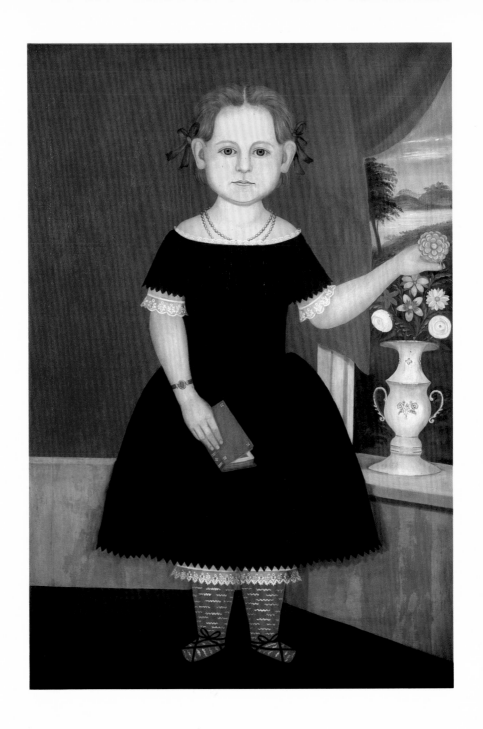

SAMUEL MILLER (active mid-19th century),
American
Emily Moulton, 1852
Oil on canvas, 40 x 27 (101.6 x 68.6)
Currier Funds and funds given in memory
of Ruth W. Higgins 1976.27

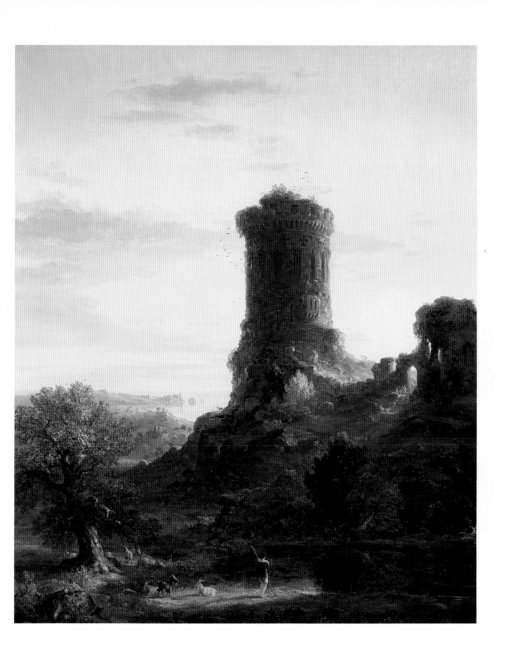

THOMAS COLE (1801–1848), American
The Tower, 1839
Oil on canvas, 18½ x 22½ (47.0 x 57.1)
Gift of the Friends 1980.7

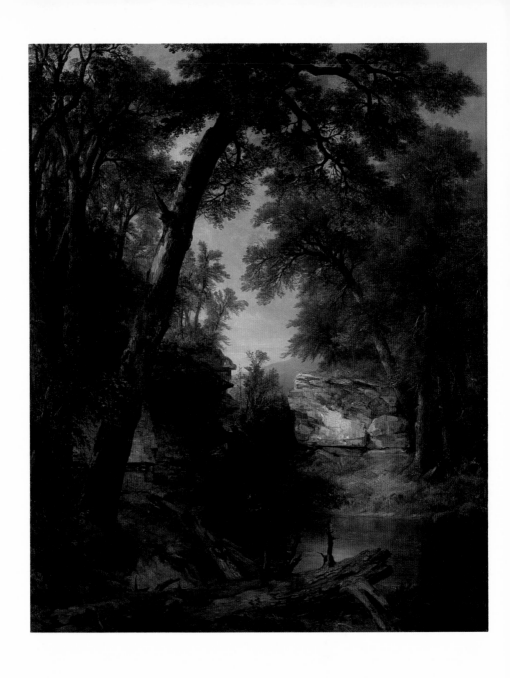

ASHER BROWN DURAND (1796–1886),
American
Reminiscence of the Catskill Clove, 1858
Oil on canvas, 39¾ x 32¼ (101.0 x 81.9)
Gift of Henry Melville Fuller 1988.26

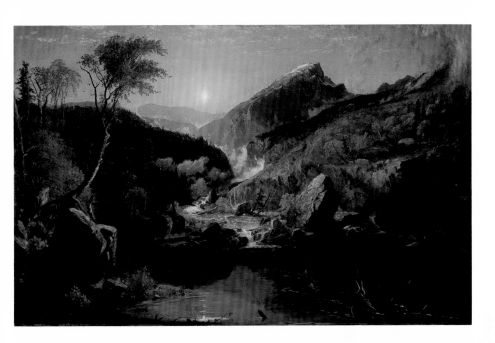

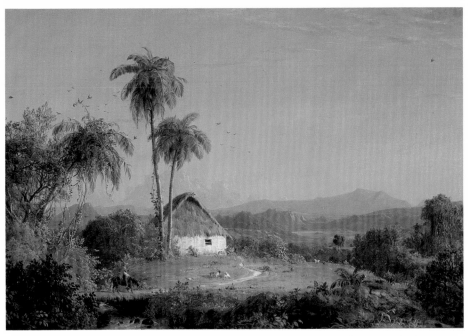

JASPER FRANCIS CROPSEY (1823–1900),
American
*Indian Summer Morning in the White
Mountains*, 1857
Oil on canvas, 39¼ x 61¼ (99.7 x 155.6)
Currier Funds 1962.17

FREDERICK EDWIN CHURCH (1826–1900),
American
South American Landscape, 1856
Oil on canvas, 14¼ x 21¼ (36.4 x 54.0)
Gift of Henry Melville Fuller 1981.68

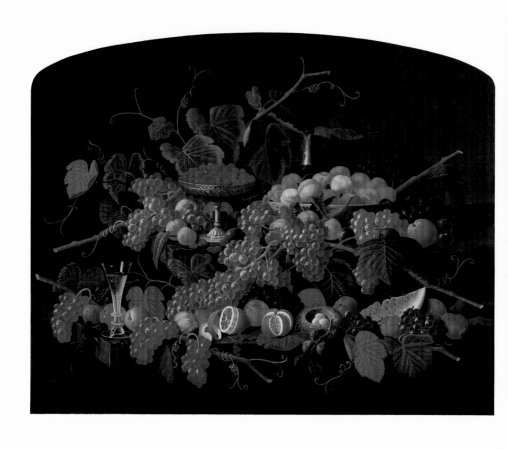

SEVERIN ROESEN (dates unknown), German
(active in America 1848–1872)
Still Life with Fruit and Champagne, c. 1865
Oil on canvas, 40 x 50 (101.6 x 127.0)
Henry Melville Fuller Fund 1984.25

MARTIN JOHNSON HEADE (1819–1904),
American
Marshfield Meadows, 1878
Oil on canvas, 17¾ x 44 (45.1 x 111.8)
Currier Funds 1962.13

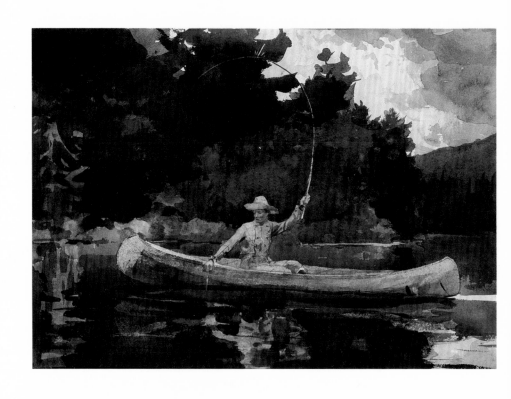

WINSLOW HOMER (1836–1910), American
The North Woods (Playing Him), 1894
Watercolor on paper,
15⅛ x 21⅜ (38.4 x 54.3)
Gift of Mr. and Mrs. Frederic H. Curtiss
1960.13

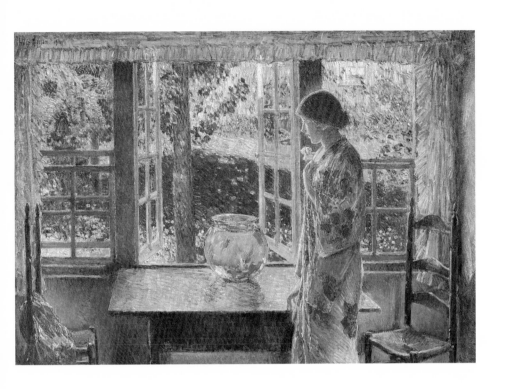

FREDERICK CHILDE HASSAM (1859–1935),
American
The Goldfish Window, 1916
Oil on canvas, 34½ x 50¾ (87.6 x 128.9)
Currier Funds 1937.2

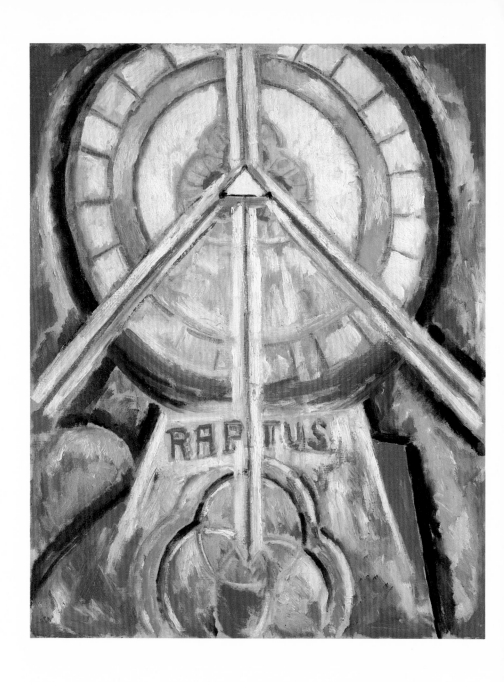

MARSDEN HARTLEY (1877–1943), American
Raptus, c. 1913
Oil on canvas, 39⅜ x 32 (100.0 x 81.3)
Gift of Paul and Hazel Strand in memory
of Elizabeth McCausland 1965.4

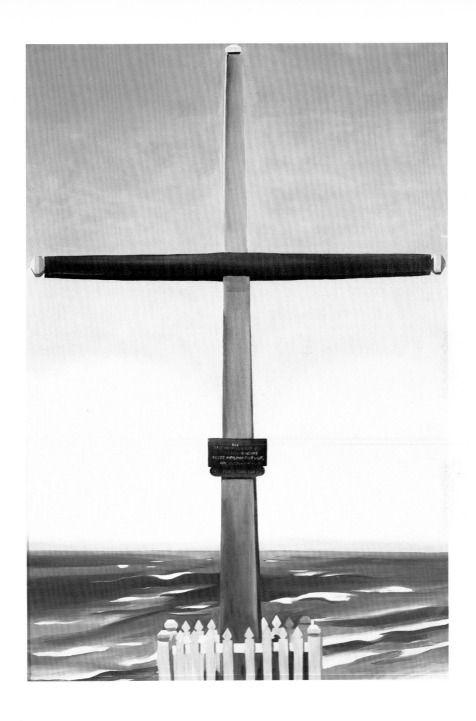

GEORGIA O'KEEFFE (1887–1986), American
Cross By the Sea, 1931
Oil on canvas, 36 x 24 (91.4 x 61.0)
Currier Funds 1960.1

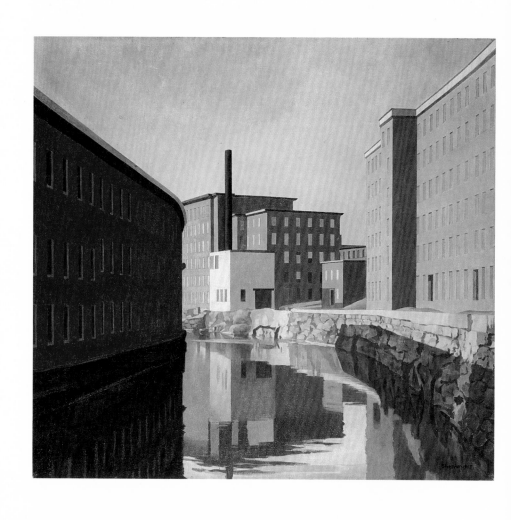

CHARLES SHEELER (1883–1966), American
Amoskeag Canal, 1948
Oil on canvas, 22⅛ x 24⅛ (56.2 x 61.3)
Currier Funds 1948.4

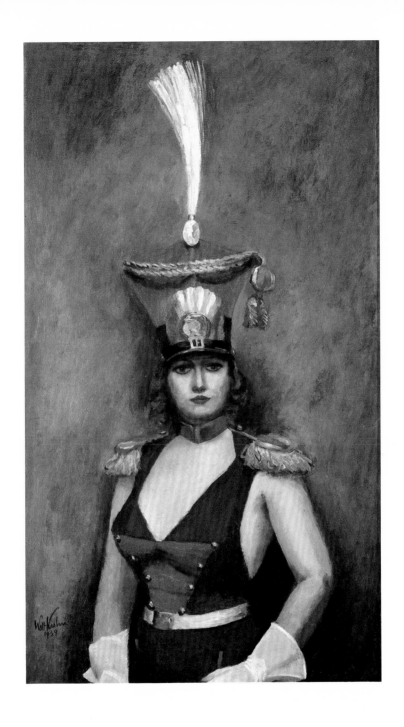

WALT KUHN (1880–1949), American
Lancer, 1939
Oil on canvas, 45½ x 26¼ (115.6 x 66.7)
Currier Funds 1958.7

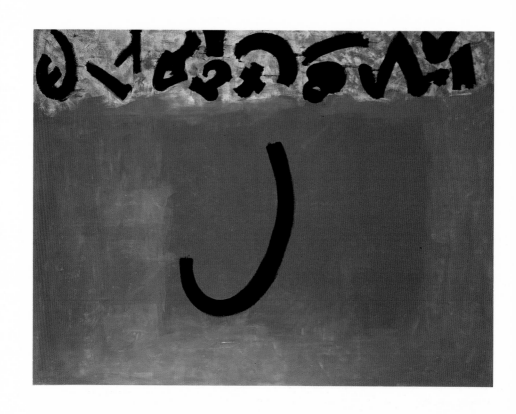

ADOLPH GOTTLIEB (1903–1974), American
From Midnight to Dawn, 1956
Oil and enamel on linen,
72 x 96 (182.8 x 243.8)
Gift of the Friends with the Rosmond
deKalb Fund and Currier Funds 1979.16

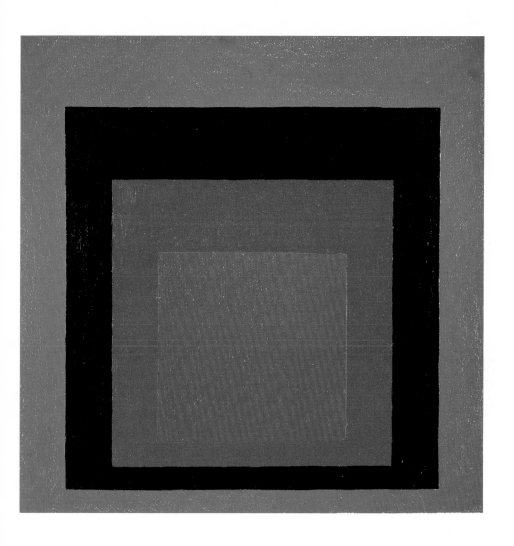

JOSEF ALBERS (1888–1976), American
*Light Blue in Red and Black Frame Against
Green,* 1957
Oil on masonite, 20 x 20 (50.8 x 50.8)
Anonymous gift 1962.18

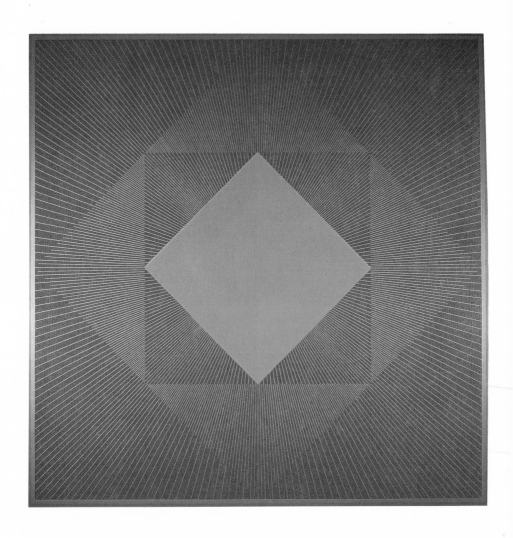

RICHARD ANUSZKIEWICZ (b. 1930),
American
Primary Contrast, 1965
Acrylic on canvas,
60¼ x 60¼ (153.0 x 153.0)
Gift of the Saul O Sidore Memorial
Foundation 1965.5

JULES OLITSKI (b. 1922), American
Shoot, 1965
Acrylic on canvas, 94 x 98 (238.8 x 248.9)
Gift of the Friends and the National
Endowment for the Arts 1977.40

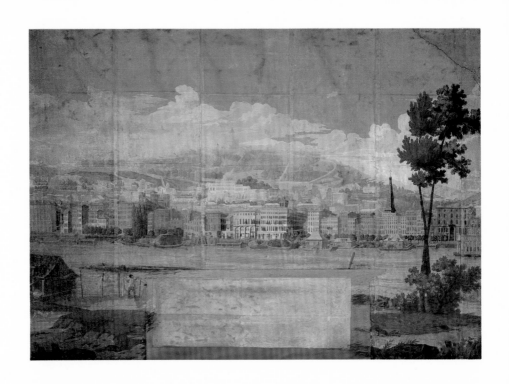

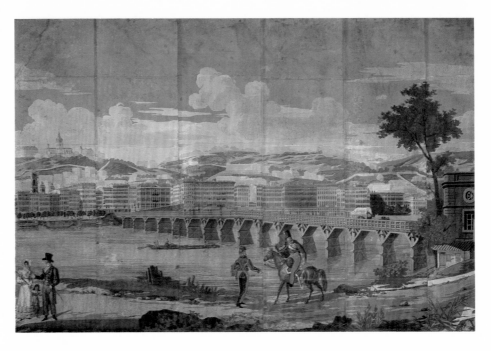

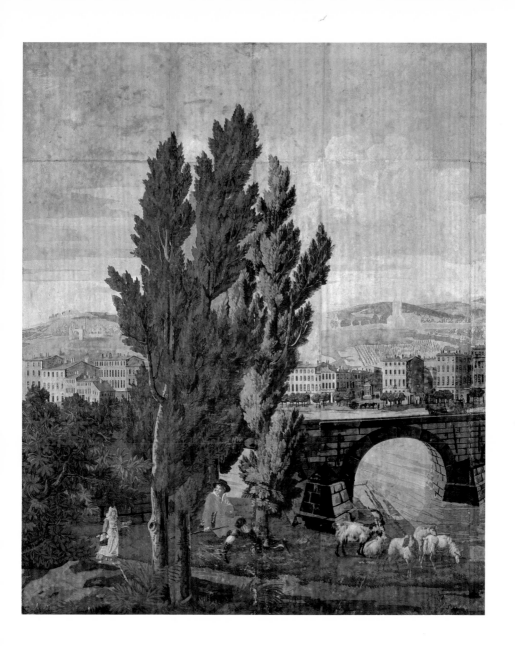

FELIX SAUVENET (dates unknown), French
View of Lyon, c. 1818
Detail, panels 1, 2 and 5 of 5
Wallpaper, 77 x 535 (195.6 x 1358.9)
Gift of Miss Penelope Snow 1928.1

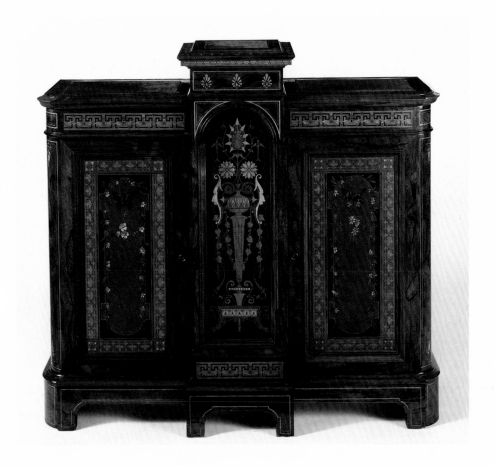

HERTER BROTHERS, New York, New York
Attributed to Christian Herter (1840–1883),
German (active in America 1860–1883)
Cabinet, 1871
Rosewood with inlay and handpainted
decoration,
47½ x 51⅞ x 18 (120.7 x 131.8 x 45.7)
Gift of the Friends 1989.9

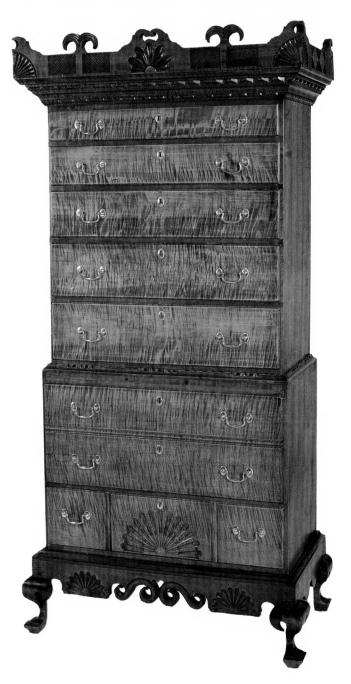

ATTRIBUTED TO THE DUNLAP FAMILY,
American
(Bedford, Goffstown, Henniker, or
Salisbury, New Hampshire)
Chest-on-chest-on-frame, c. 1785
Tiger maple,
82⅝ x 36 x 16⅞ (109.9 x 91.4 x 42.9)
Currier Funds 1959.3

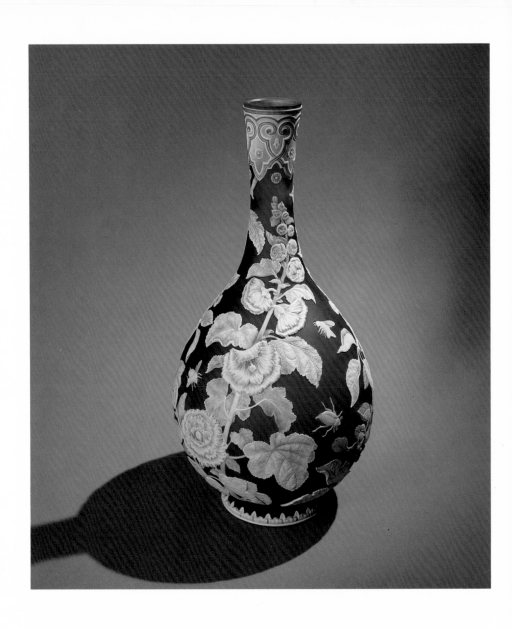

GEORGE WOODALL (1850–1925) and
THOMAS WOODALL (1849–1926), English
Vase, c. 1885
Three color cameo cut glass,
18 x 8¼ (45.7 x 20.9)
Murray Collection of Glass 1974.33.6

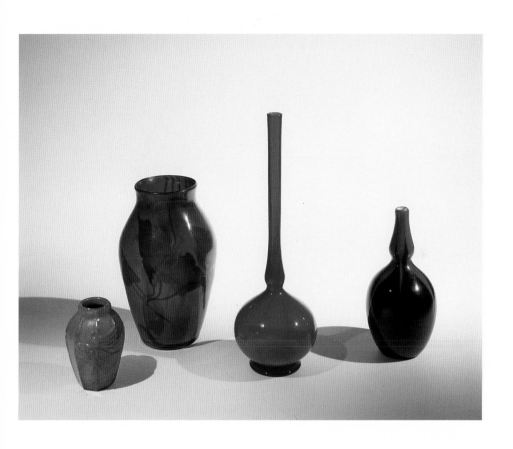

LOUIS COMFORT TIFFANY (1848–1933),
American
Vases Left to right:
Carved yellow-green vase, 1906
3¾ x 2¾ x 2¾ (9.4 x 7 x 7)
Paper-weight type, multi-colored vase, 1913
7¾ x 4⅞ (19.6 x 12.3)

Bottle-shaped vase, 1916
11⅜ x 4 (29.1 x 10.2)
Bottle-shaped vase, 1916
7 x 3½ (17.8 x 8.9)
Murray Collection of Glass
1974.33.256, 293, 296 and 295

European Painting

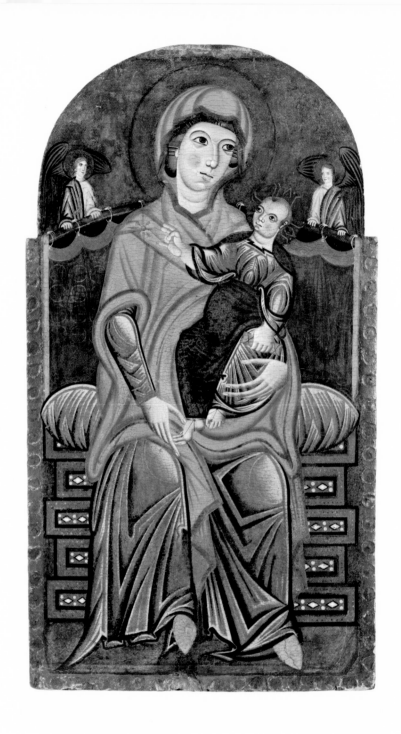

FOLLOWER OF MELIORE, Italian
Madonna and Child with Angels, c. 1275
Tempera on canvas mounted on panel,
36⅝ x 20¼ (93.0 x 51.5)
Currier Funds 1954.5

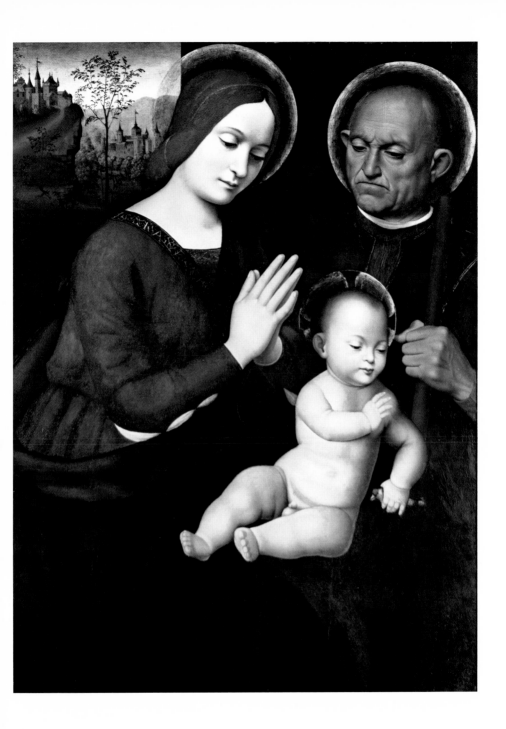

ANTONIO RIMPATTA (active c. 1509–
1531/32), Italian
Madonna and Child with St. Joseph,
c. 1509–1511
Tempera on panel, 30½ x 25¾ (77.5 x 65.4)
Bequest of Mr. Edward Dane 1987.7

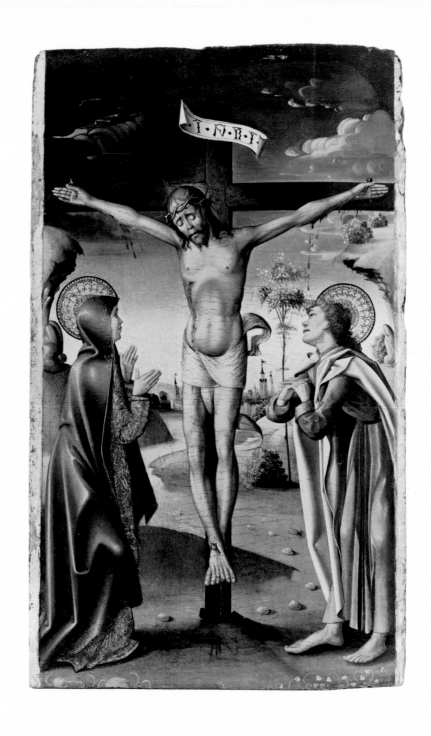

ASTORGA MASTER (active 1510–1530),
Spanish
Crucifixion, c. 1520
Oil on panel, 34½ x 20⅝ (87.6 x 52.4)
Currier Funds 1968.1

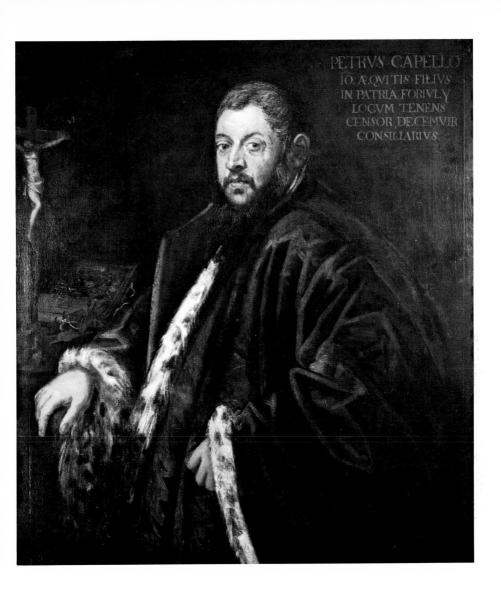

JACOPO ROBUSTI called TINTORETTO
(1518–1594), Italian
*Pietro Capello, Governor of the Venetian
Province of Friuli*, c. 1586
Oil on canvas, 42 x 37 (106.7 x 94.0)
Mabel Putney Folsom Fund 1949.5

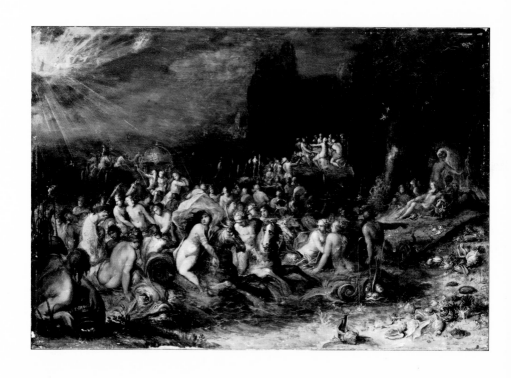

FRANS FRANCKEN THE YOUNGER
(1581–1656), Flemish
Triumph of Neptune and Amphitrite, 1607
Oil on panel, 13½ x 19 (34.3 x 48.2)
Anonymous gift 1962.16

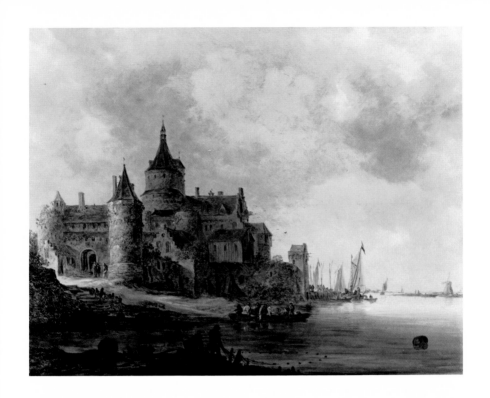

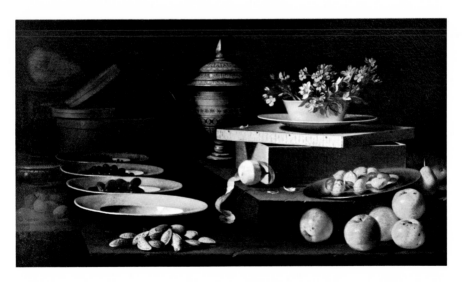

JAN VAN GOYEN (1596–1656), Dutch
Fort Lillo on the Scheldt, 1643
Oil on panel, 24⅜ x 31⅛ (61.9 x 79.1)
Currier Funds 1961.17

ATTRIBUTED TO EVARISTO BASCHENIS
(1607–1677), Italian
Still Life with Fruits and Spices, c. 1650
Oil on canvas, 22 x 38½ (55.9 x 97.8)
Currier Funds 1959.1

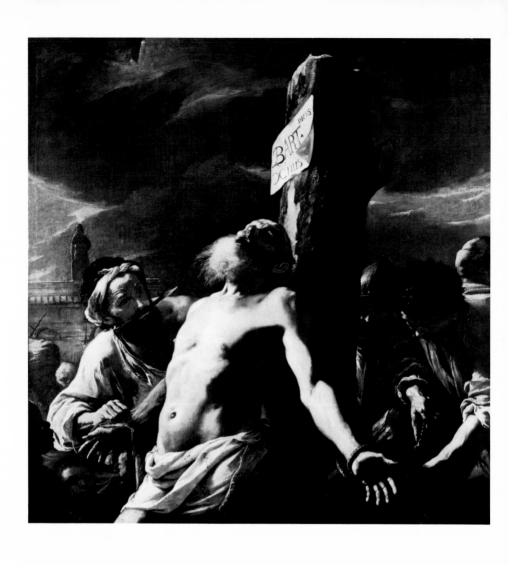

MATTIA PRETI (1613–1669), Italian
Martyrdom of St. Bartholomew, c. 1655–56
Oil on canvas, 74 x 74 (188.0 x 188.0)
Currier Funds 1970.25

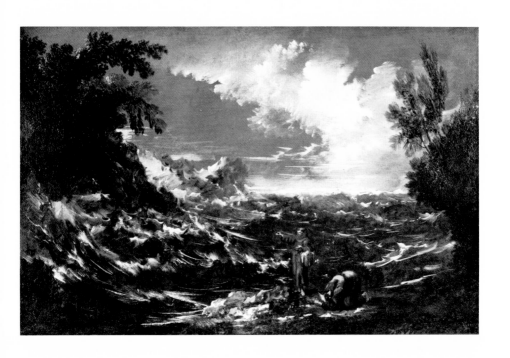

ALESSANDRO MAGNASCO (1667–1749),
Italian
Monks on a Stormy Shore, c. 1710
Oil on canvas, 22 x 33½ (55.9 x 85.1)
Anonymous Gift 1972.19

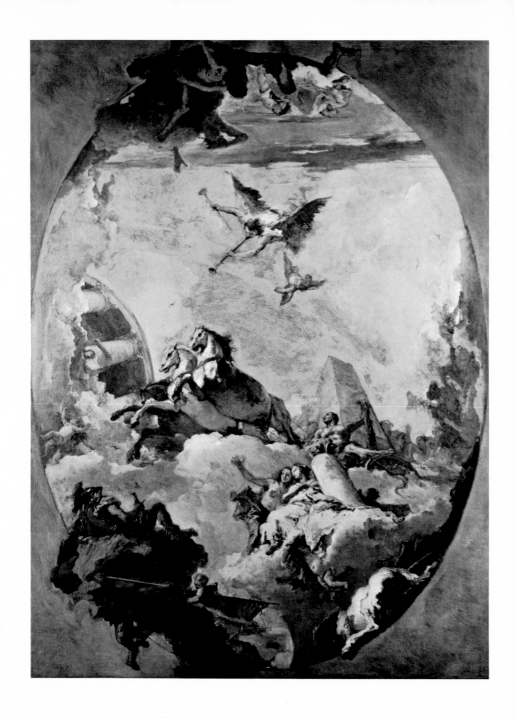

GIOVANNI-BATTISTA TIEPOLO
(1696–1770), Italian
Triumph of Hercules, c. 1761
(Modello for ceiling fresco in the
Palazzo Canossa, Verona)
Oil on canvas, 36½ x 27½ (92.7 x 69.8)
Currier Funds 1959.10

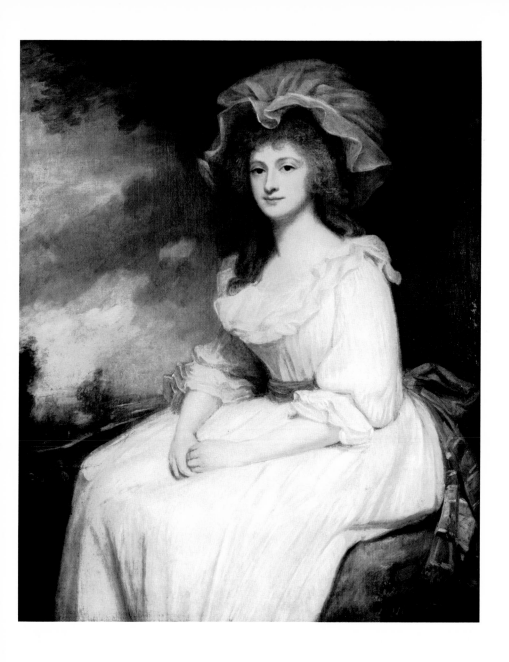

GEORGE ROMNEY (1734–1802), English
Mrs. Anne Blackburn, 1790
Oil on canvas, 50½ x 40⅝ (128.3 x 103.2)
Gift of Mr. Sosthenes Behn, New York
1954 (308)

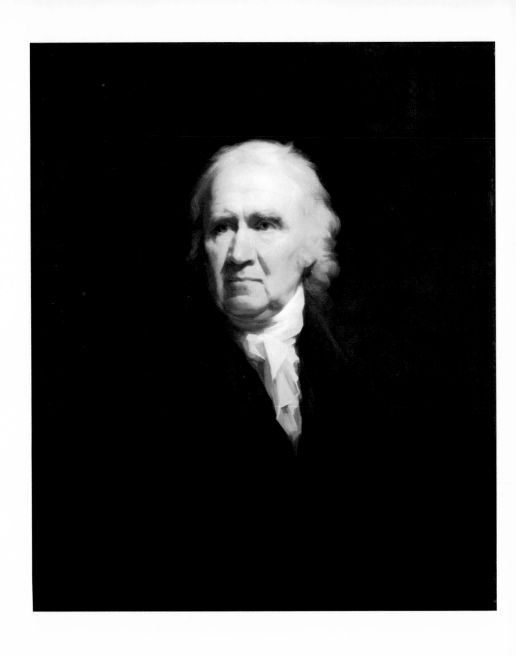

SIR HENRY RAEBURN (1758–1823), Scottish
John Clerk of Eldin, c. 1800
Oil on canvas, 30¼ x 25⅛ (76.8 x 63.8)
Currier Funds 1933.8

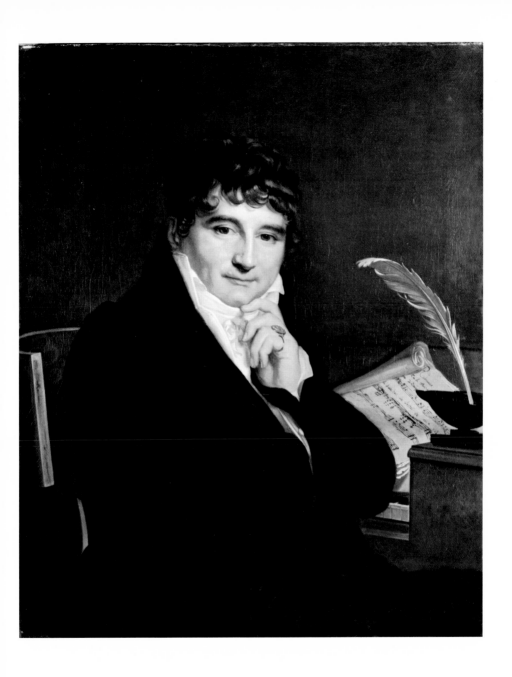

PAULINE AUZOU (1775–1835), French
Portrait of a Musician, 1809
Oil on canvas, 32 x 25¾ (81.3 x 65.4)
Ralph W. Fracker Fund 1973.14

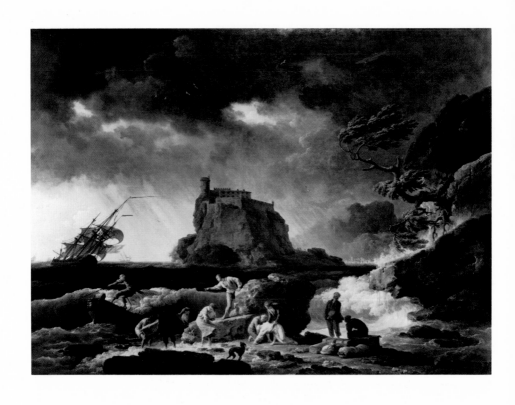

CLAUDE JOSEPH VERNET (1714–1789),
French
The Storm, 1759
Oil on canvas, 38½ x 53 (97.8 x 134.6)
Jennie F. Fracker and Inez M. Olney Funds
1977.27

66

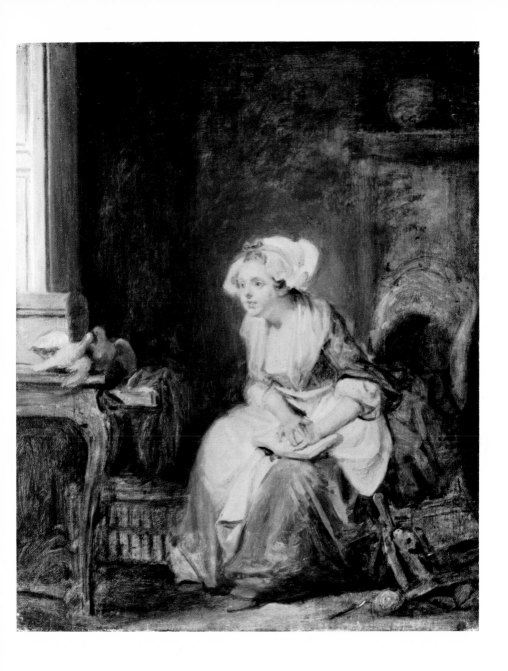

JEAN-BAPTISTE GREUZE (1725–1805),
French
First Lesson in Love, c. 1760
Oil on canvas, 15⅝ x 12⅝ (39.7 x 32.1)
Currier Funds 1976.26

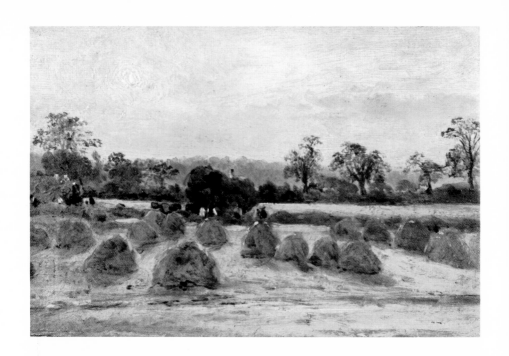

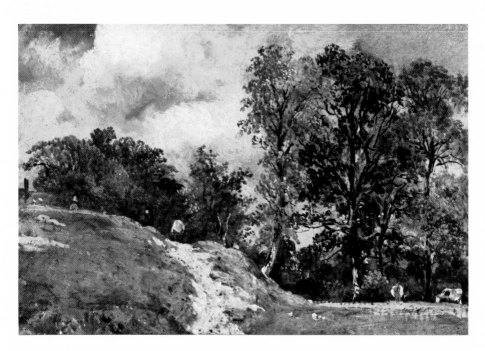

JOHN CONSTABLE (1776–1837), English
Hayfield at Moulsey, Surrey, 1829
Oil on panel, 4½ x 6¾ (11.4 x 17.2)
Gift of Mr. and Mrs. W. Prescott Smith
1979.14

JOHN CONSTABLE (1776–1837), English
Banks of the Itchen Hants, 1829
Oil on panel, 4½ x 6¾ (11.4 x 17.2)
Gift of Mr. and Mrs. W. Prescott Smith
1978.98

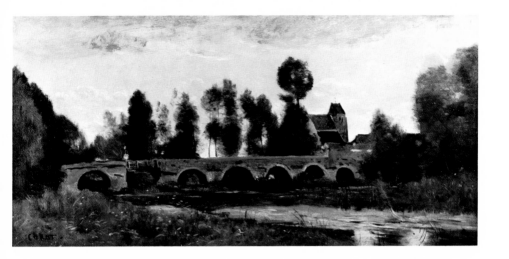

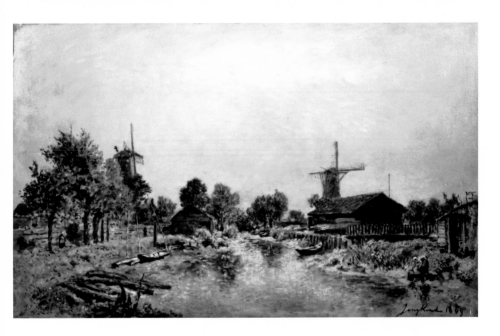

JEAN-BAPTISTE-CAMILLE COROT
(1796–1875), French
The Bridge at Grez-sur-Loing, 1850–60
Oil on canvas, 12⅛ x 25 (30.8 x 63.5)
Currier Funds 1949.7

JOHAN BARTHOLD JONGKIND (1819–1891),
Dutch
The Meuse in the Vicinity of Rotterdam,
1869
Oil on canvas, 15¾ x 25¾ (40.0 x 65.4)
Gift of Count Cecil Pecci-Blunt 1961.15

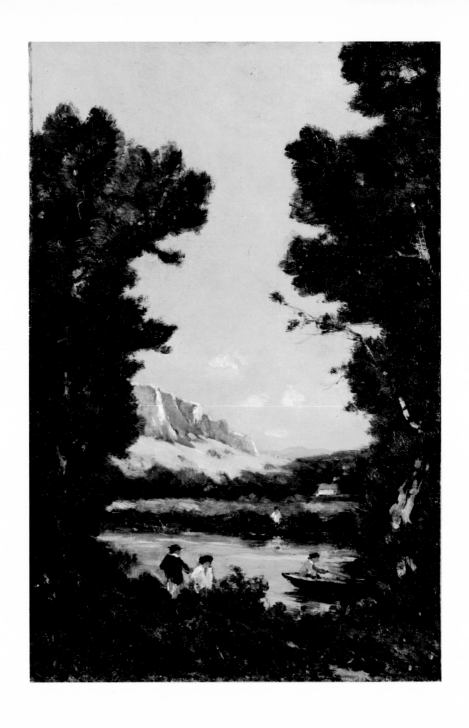

HENRI-JOSEPH HARPIGNIES (1819–1916),
French
Landscape in the South of France, 1877
Oil on canvas, 16½ x 11 (41.9 x 27.9)
Bequest of Florence Andrews Todd
1937 PCT 16 (169)

LAURA ALMA-TADEMA (1852–1909),
English
A Knock at the Door, 1897
Oil on panel, 25⅛ x 17⅝ (63.8 x 44.8)
Bequest of Florence Andrews Todd
1937 PCT 15 (169)

European Sculpture

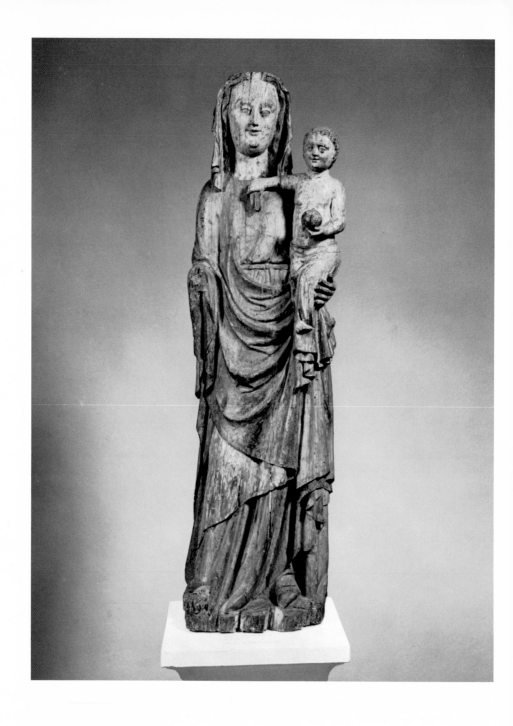

ARTIST UNKNOWN, French
Madonna and Child, c. 1350
Wood,
40¾ x 12½ x 7¾ (103.5 x 31.7 x 19.7)
Currier Funds 1940.2

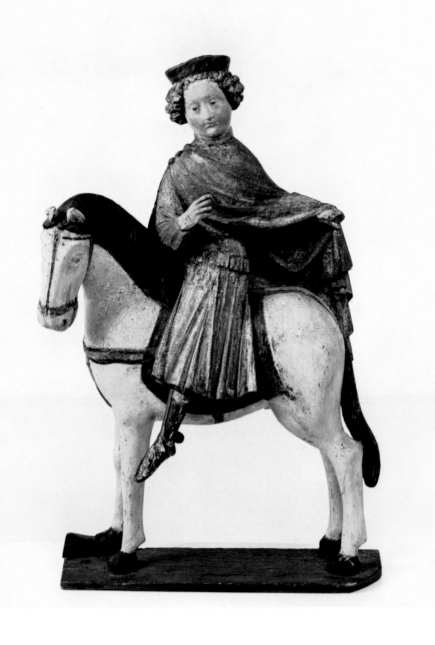

ARTIST UNKNOWN, German
St. Martin on Horseback, c. 1400
Painted wood, 34½ x 21 x 10
(87.6 x 53.3 x 25.4)
Gift of the Friends and
Florence Andrews Todd Funds 1988.16

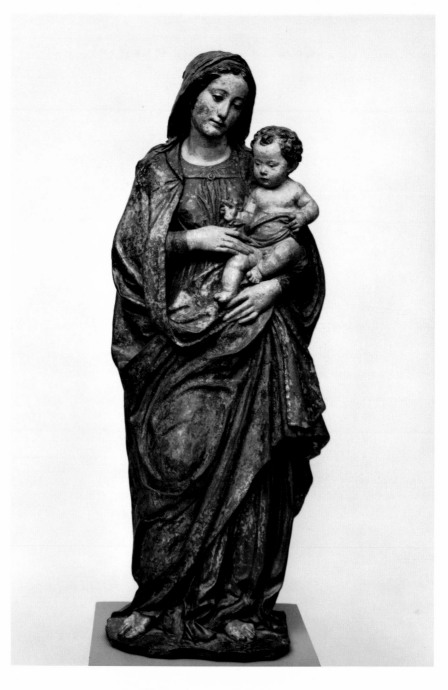

BENEDETTO DI LEONARDO called
BENEDETTO DA MAIANO (1442–1497),
Italian
Madonna and Child, c. 1480
Painted terracotta,
42 x 17 x 8¾ (106.7 x 43.2 x 22.2)
Currier Funds 1945.3

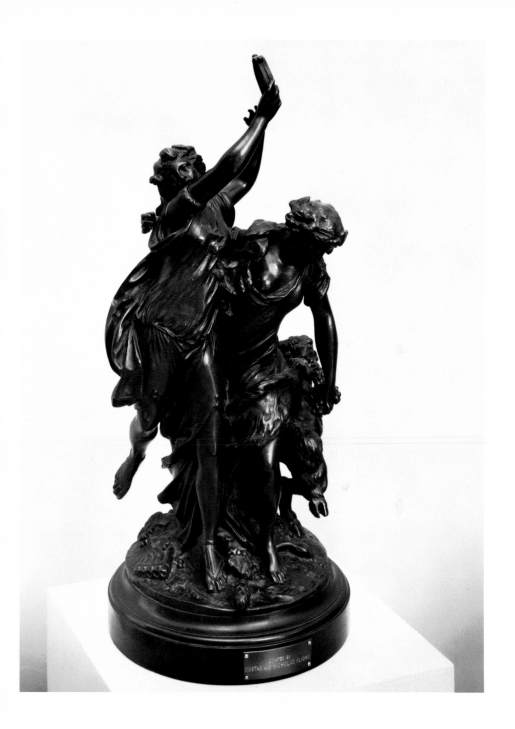

CLAUDE MICHEL called CLODION
(1738–1814), French
Two Nymphs and a Satyr, 1762
Bronze, 33 x 16 x 6½ (83.8 x 40.6 x 16.5),
including base
Gift of Costas and Nicholas Flione

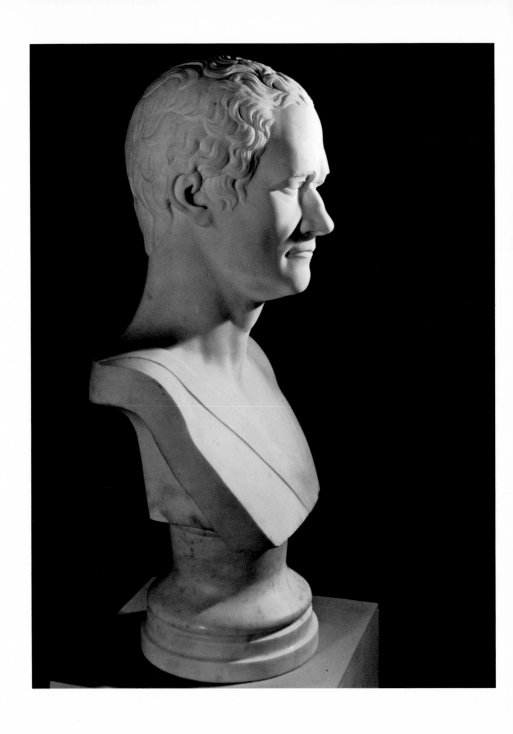

GIUSEPPE CERACCHI (1751–1801), Italian
Alexander Hamilton, 1794
Marble,
26¼ x 13¾ x 10¼ (66.7 x 34.9 x 26.0)
Currier Funds 1968.2

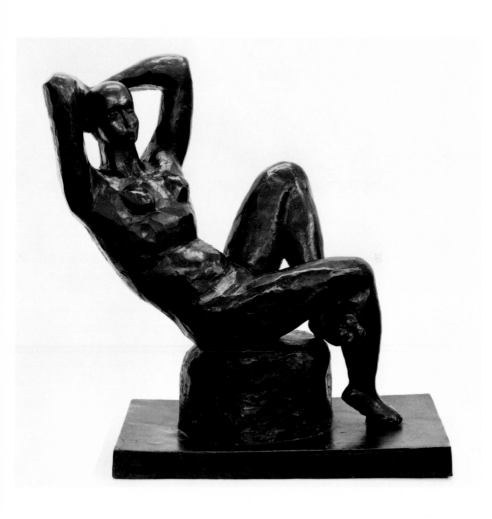

HENRI MATISSE (1869–1954), French
Seated Nude, 1922–25
Bronze, 31 x 32 x 14 (78.7 x 81.3 x 35.6)
Currier Funds 1964.1

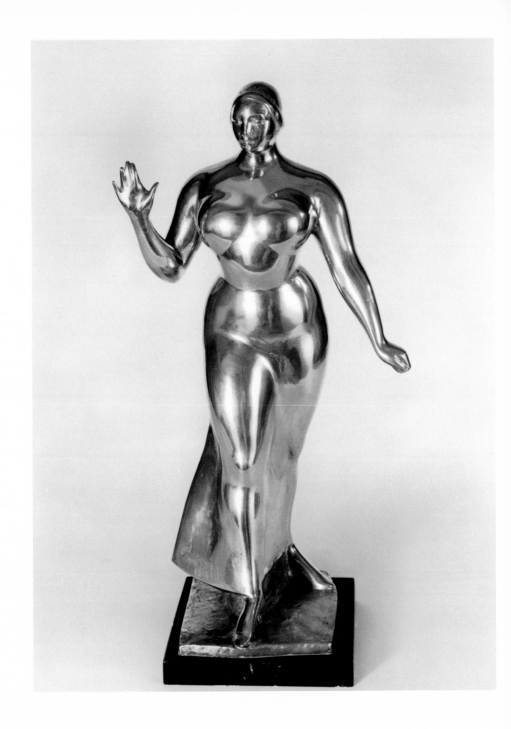

GASTON LACHAISE (1881–1935), French
Walking Woman, 1922
Polished bronze, black marble base,
19⅝ x 10½ x 7 (49.9 x 26.7 x 17.8)
Gift of Dr. Isadore J. and
Lucille Zimmerman 1982.26

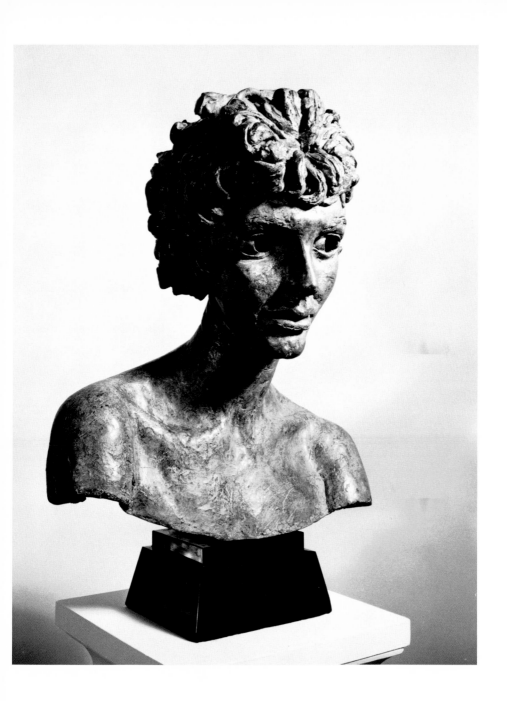

SIR JACOB EPSTEIN (1880–1959), English
Kitty III, 1957
Bronze, 19¾ x 16⅛ x 11 (50.2 x 41.0 x 27.9)
Gift of Dr. Isadore J. and
Lucille Zimmerman in memory of
Dr. Simon Stone 1964.6

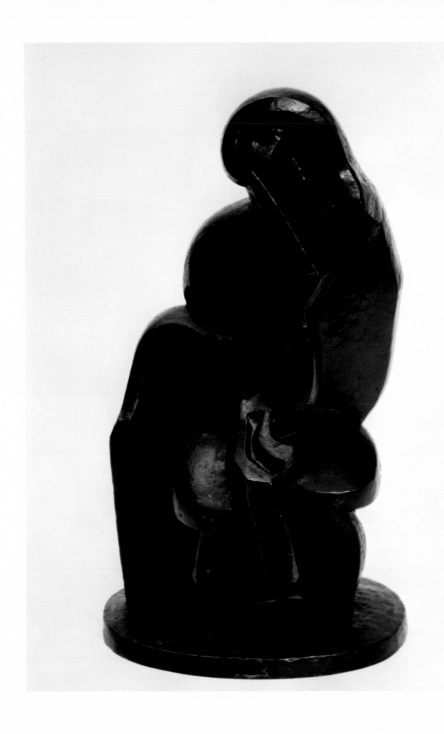

JACQUES LIPCHITZ (1891–1973), Lithuanian
(active in France and America)
Seated Bather, 1924
Bronze, 15 x 7 x 6¼ (38.1 x 17.8 x 15.9)
Currier Funds 1963.2

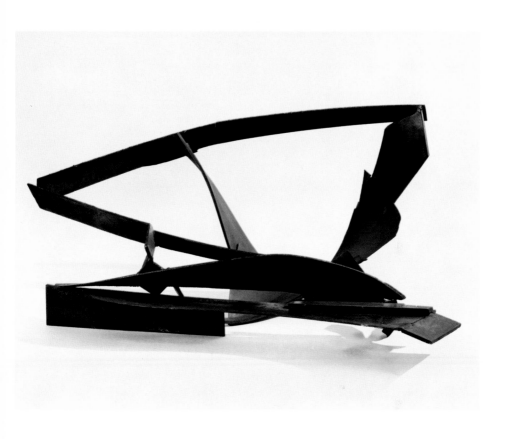

ANTHONY CARO (b. 1924), English
Table Piece C91, 1975–77
Steel and sheet steel, rusted and varnished,
19⅝ x 42 x 26½ (49.9 x 106.7 x 67.3)
Rosmond deKalb Fund, Currier Funds, and
Gift of G. Peabody Gardner III 1982.41

American Painting

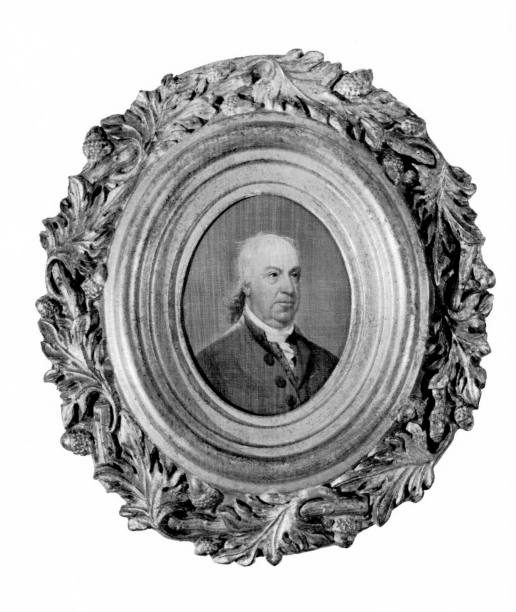

JOHN TRUMBULL (1756–1843)
Judge Samuel Livermore, 1792
Oil on panel, 4 x 3⅛ (10.2 x 7.9)
Currier Funds 1946.4

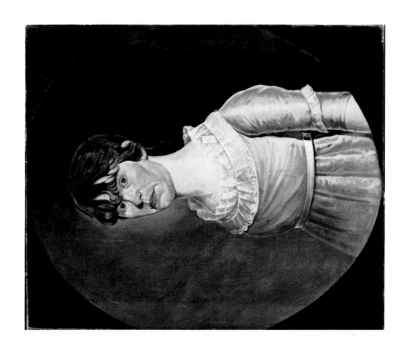

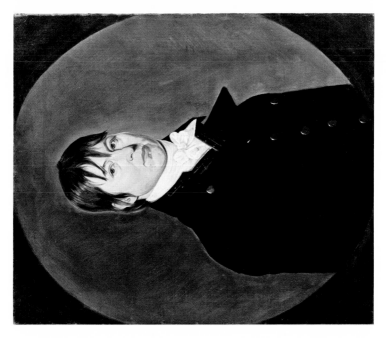

WILLIAM JENNYS (active 1795–1810)
Portrait of a Man, 1802–05
Oil on canvas, 30⅞ x 25½ (78.4 x 64.7)
Gift of the Friends 1966.3

WILLIAM JENNYS (active 1795–1810)
Portrait of a Woman, 1802–05
Oil on canvas, 30⅞ x 25⅝ (78.4 x 65.1)
Gift of the Friends 1966.4

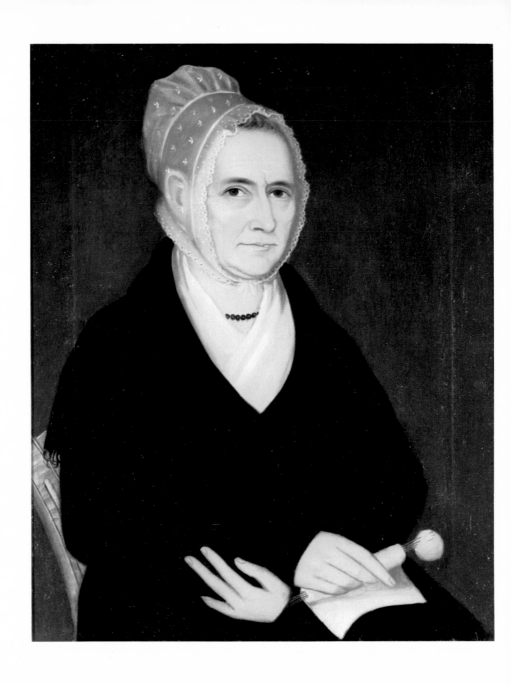

AMMI PHILLIPS (1788–1865)
Ruth Roe Sleight, c. 1820–25
Oil on canvas, 29½ x 23½ (74.9 x 59.7)
Gift of Robert L. Williston in loving
memory of his wife Marian J. Williston,
descendent of the sitter 1982.27.2

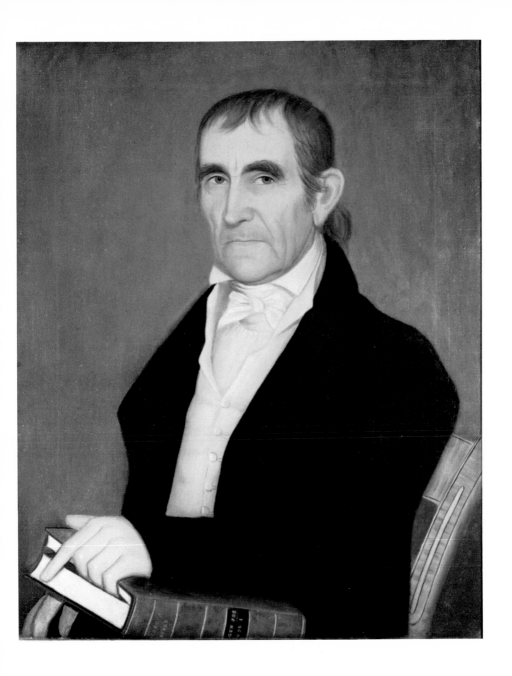

AMMI PHILLIPS (1788–1865)
Abraham Sleight, c. 1820–25
Oil on canvas, 29½ x 23½ (74.9 x 59.7)
Gift of Robert L. Williston in loving
memory of his wife Marian J. Williston,
descendent of the sitter 1982.27.1

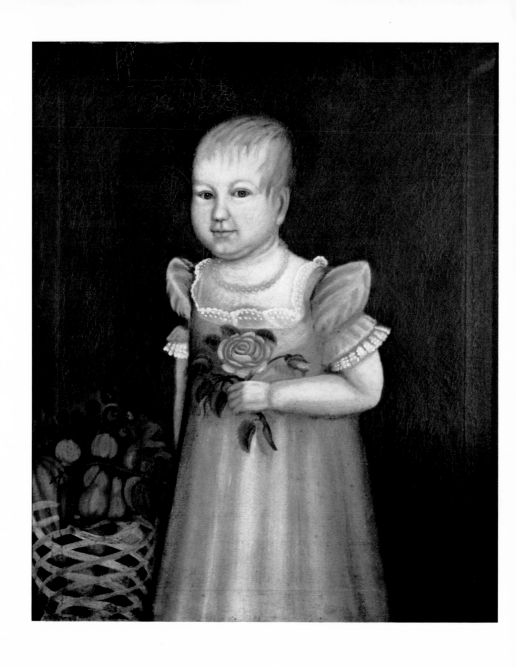

ATTRIBUTED TO ZEDEKIAH BELKNAP
(1781–1858), Bedford, New Hampshire
Portrait of Mary Anne Riddle, c. 1825
Oil on canvas, 26 x 21⅞ (66.0 x 55.6)
Purchased in honor of Robert M. Doty
1987.24

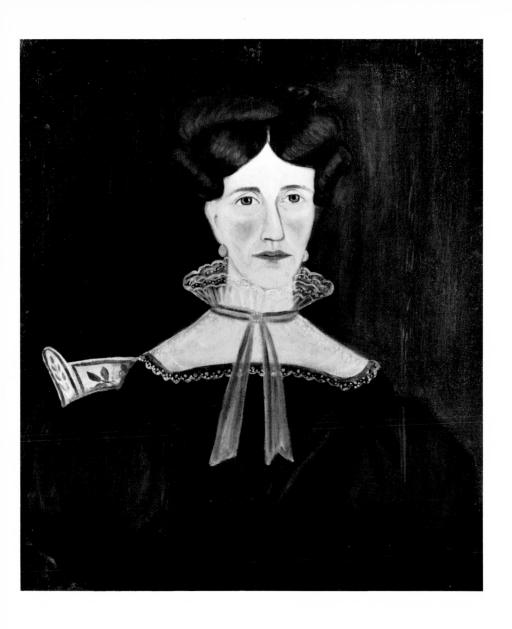

RUTH W. SHUTE (1803–1882) and
SAMUEL A. SHUTE (1803–1836), Milford,
New Hampshire
Portrait of Sarah Whitmarsh, 1833
Oil on canvas, 30⅛ x 26 (76.5 x 66.0)
Gift of James and Barbara Crosby Enright
1982.62

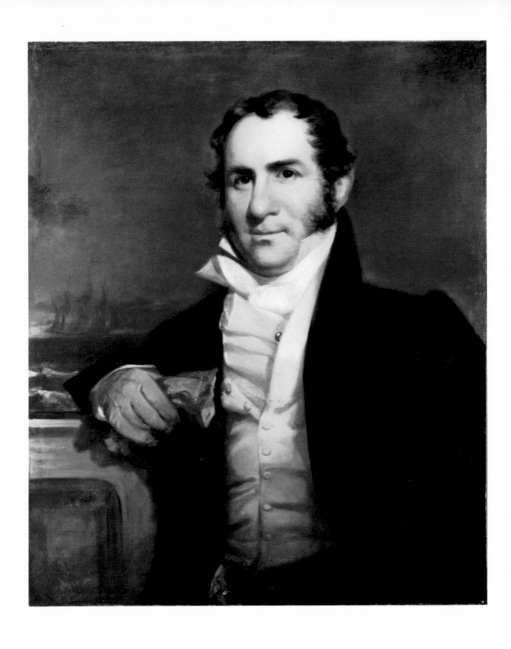

JOHN NEAGLE (1796–1865)
Portrait of Captain Smith, c. 1830
Oil on canvas, 35 x 30 (89.0 x 76.2)
Gift of the Friends 1978.33

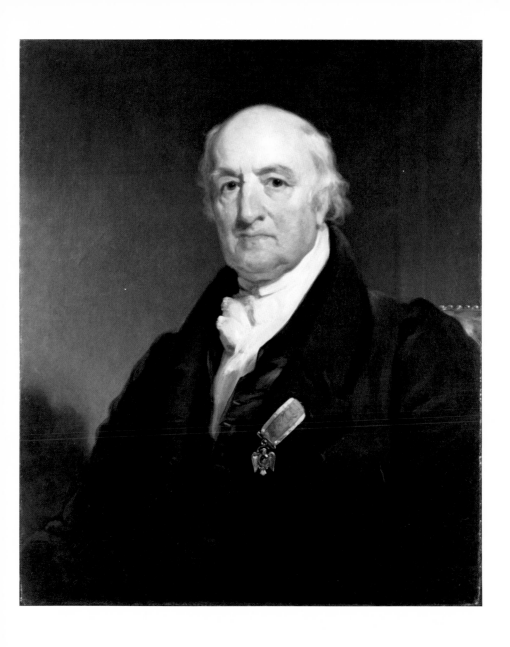

HENRY INMAN (1801–1846)
Colonel Richard Varick, 1831
Oil on canvas, 30 x 25 (76.2 x 63.5)
Gift of Richard Varick 1941.2.1

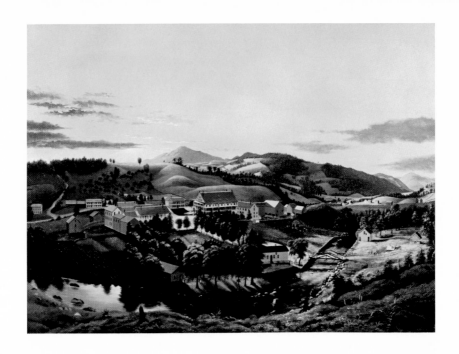

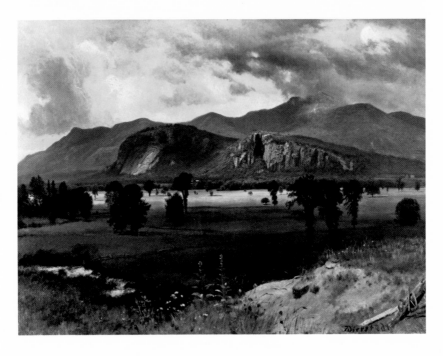

JAMES HOPE (1818–1892), born Scotland
Clarendon Springs, Vermont, 1853
Oil on canvas, 26 x 36 (66.0 x 91.5)
Gift of the Friends 1970.1

ALBERT BIERSTADT (1830–1902)
Moat Mountain, Intervale, New Hampshire,
c. 1862
Oil on canvas, 19⅛ x 25⅞ (48.6 x 65.7)
Currier Funds 1947.3

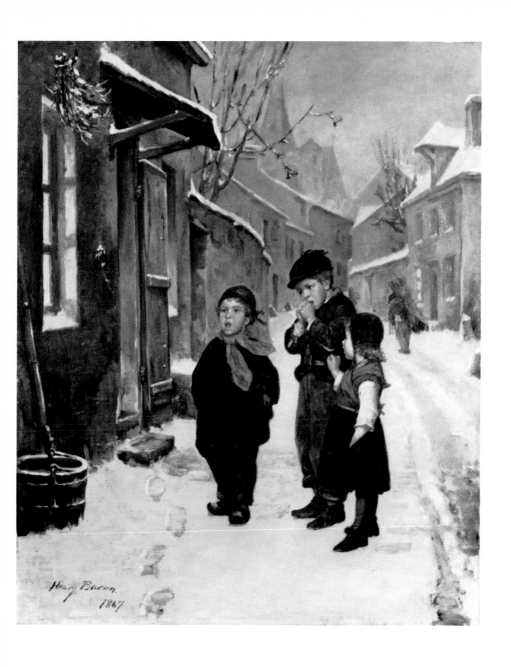

HENRY BACON (1839–1912)
Carol Singers, 1867
Oil on canvas, 16¼ x 13¼ (41.3 x 33.7)
Gift of Mrs. Rhoda Shaw Clark 1976.29

CHARLES CALEB WARD (1831–1896)
Force and Skill, 1869
Oil on canvas, 12 x 10 (30.5 x 25.4)
Gift of Henry Melville Fuller 1971.25

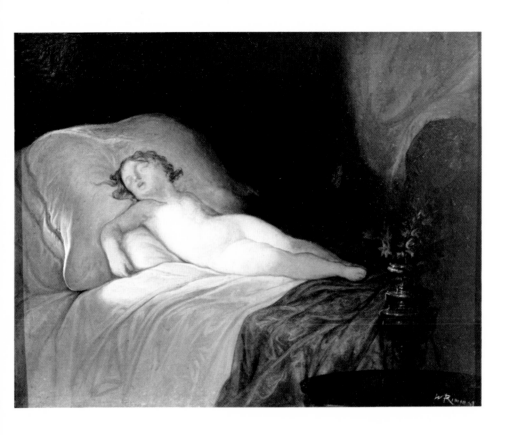

WILLIAM HENRY RIMMER (1816–1879)
Sleeping, c. 1878
Oil on academy board, 8 x 10½ (20.3 x 26.7)
Gift of the Friends 1985.41

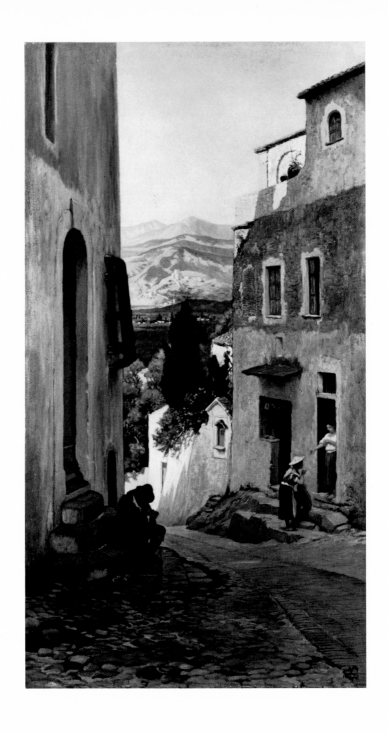

ELIHU VEDDER (1836–1923)
Bordighera, 1872
Oil on canvas, 27⅝ x 15⅛ (70.2 x 38.4)
Gift of the Friends 1967.1

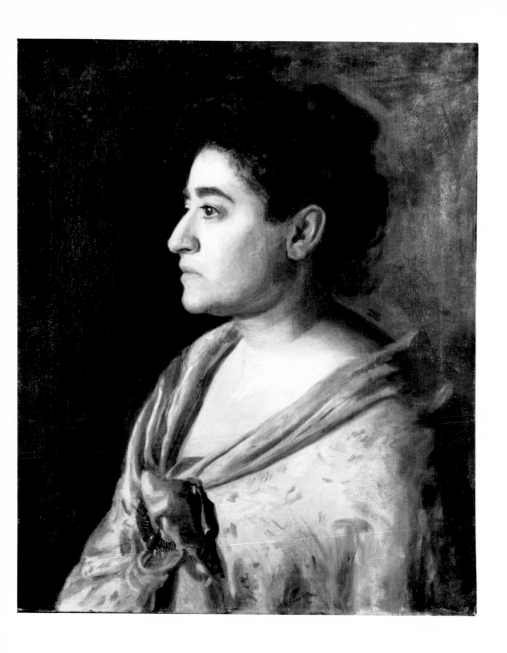

THOMAS EAKINS (1844–1916)
Miss Florence Einstein, 1905
Oil on canvas, 24 x 20 (60.9 x 50.8)
Henry Melville Fuller Fund and Currier
Funds 1979.25

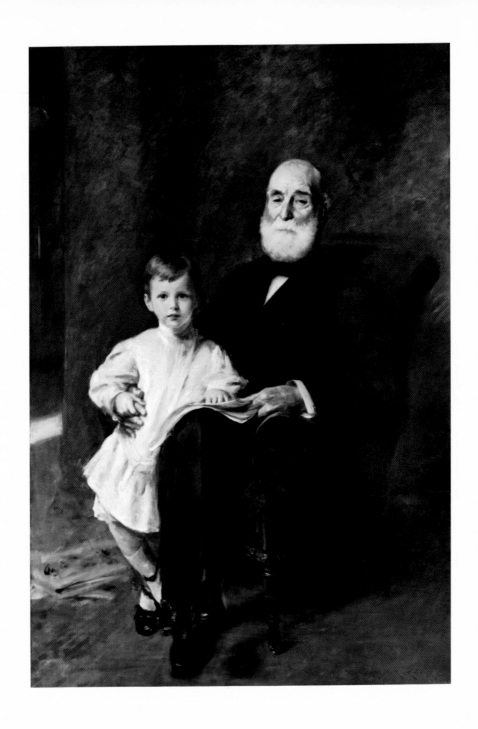

WILLIAM MERRITT CHASE (1849–1916)
*Portrait of Master Otis Barton and his
Grandfather,* 1903
Oil on canvas, 65 x 45 (165.1 x 114.3)
Gift of Otis Barton 1980.83

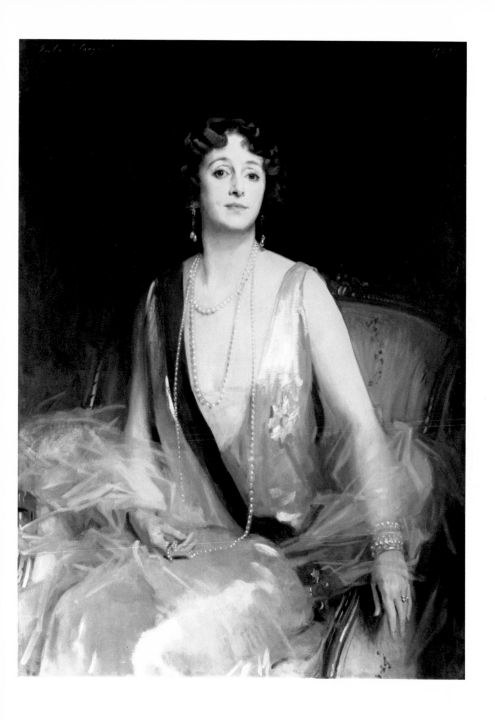

JOHN SINGER SARGENT (1856–1925)
*Portrait of Marchioness Curzon of
Kedleston*, 1925
Oil on canvas, 50 x 36½ (127.0 x 92.7)
Currier Funds 1936.5

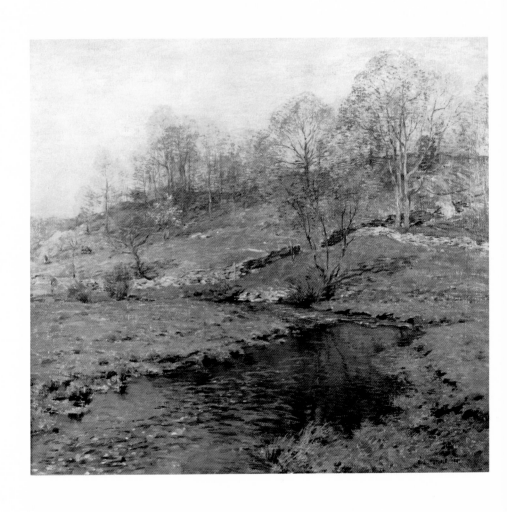

WILLARD L. METCALF (1848–1925)
The Trout Brook, 1907
Oil on canvas, 26 x 29 (66.0 x 73.7)
Bequest of Miss Louisa A. Wells 1945.4.1

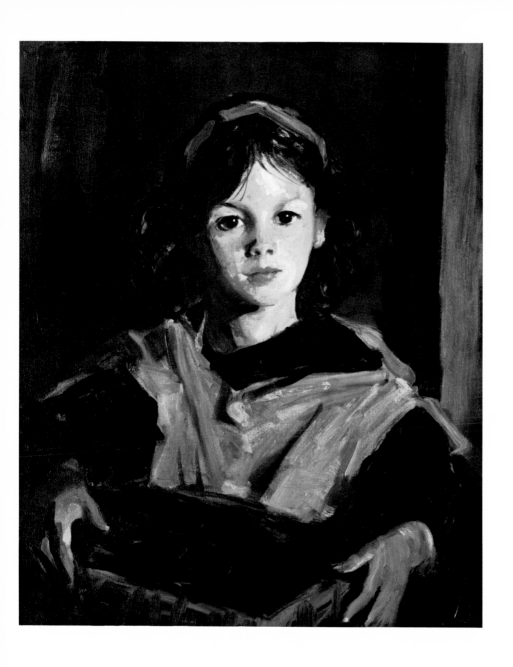

ROBERT HENRI (1865–1929)
Mary Anne with her Basket, c. 1910
Oil on canvas, 24 x 19 (61.0 x 48.3)
Currier Funds 1939.6

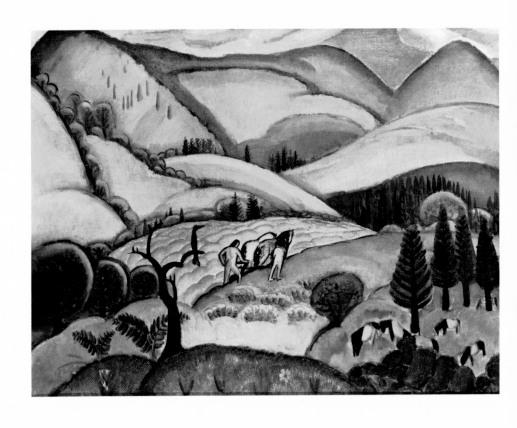

WILLIAM ZORACH (1887–1966)
Plowing the Fields, 1917
Oil on canvas, 24 x 36 (61.0 x 91.4)
Gift of Dr. and Mrs. R. Huntington Breed II,
Mrs. Elenore Freedman, the Friends,
Mr. and Mrs. Saul Greenspan, Mr. and

Mrs. James W. Griswold, Mr. and Mrs.
Robert C. Holcombe, Mr. and Mrs. John F.
Swope, Mr. and Mrs. Davis P. Thurber,
and Mr. and Mrs. Kimon S. Zachos
1987.4

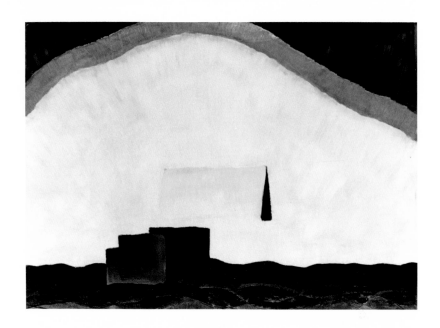

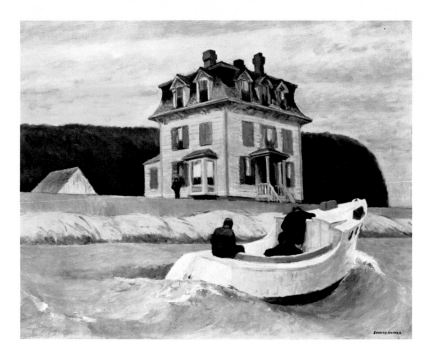

ARTHUR DOVE (1880–1946)
Snow and Water, 1928
Oil on aluminum, 20 x 27½ (50.8 x 69.8)
Gift of Paul and Hazel Strand 1975.22

EDWARD HOPPER (1882–1967)
The Bootleggers, 1925
Oil on canvas, 30⅛ x 38 (76.5 x 96.5)
Currier Funds 1956.4

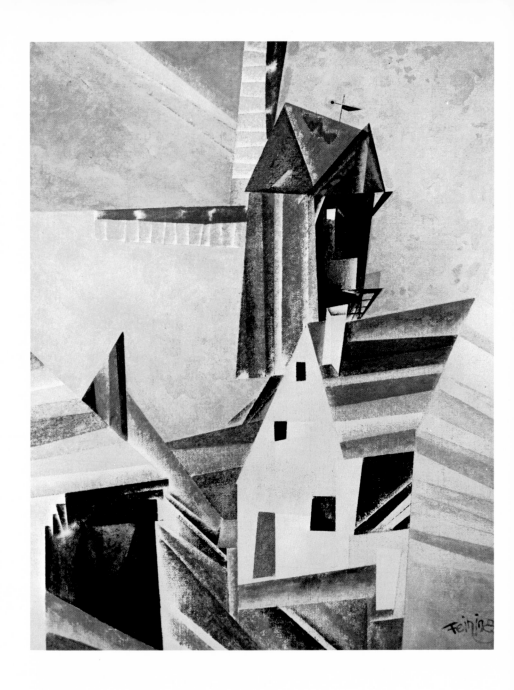

LYONEL FEININGER (1871–1956)
The Mill in Spring, 1935
Oil on canvas, 39⅞ x 32 (101.3 x 81.3)
Currier Funds 1957.1

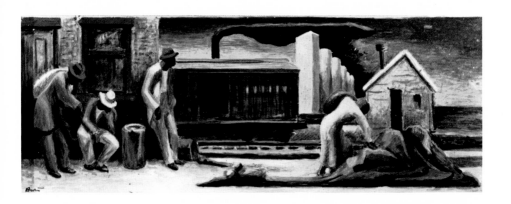

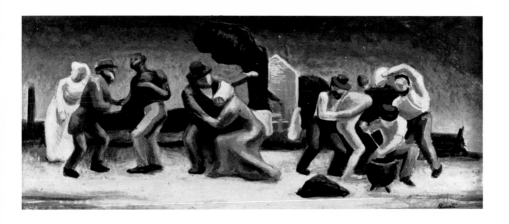

THOMAS HART BENTON (1889–1975)
History of Missouri: City Slums, 1935
Oil on masonite, 5½ x 14⅛ (14.0 x 35.9)
Gift of Mrs. Caroline Robie (1958) 333

THOMAS HART BENTON (1889–1975)
History of Missouri: Mormons, 1935
Oil on masonite, 4¾ x 11⅜ (12.0 x 28.9)
Gift of Mrs. Caroline Robie (1958) 332

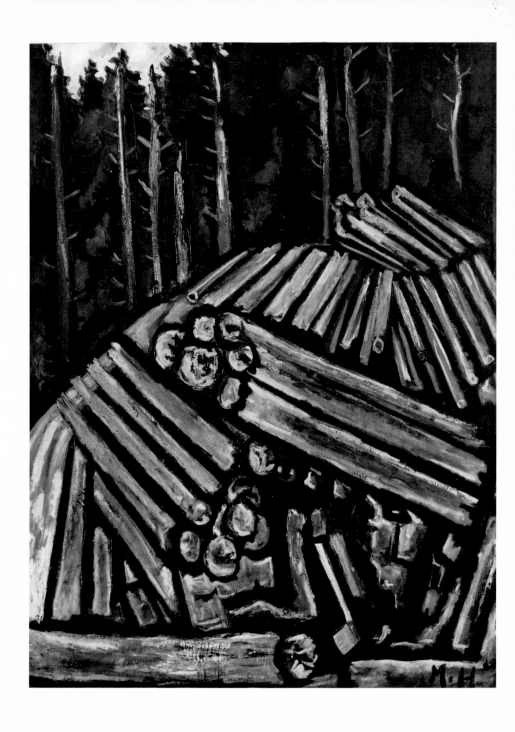

MARSDEN HARTLEY (1877–1943)
Abundance, 1939–40
Oil on canvas, 40⅛ x 30 (102.0 x 76.2)
Currier Funds 1959.2

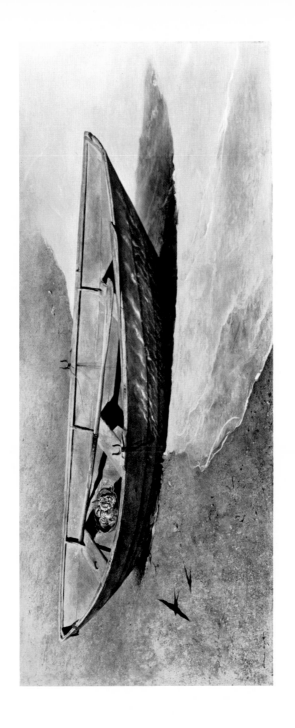

ANDREW WYETH (b. 1917)
Spindrift, 1950
Tempera on masonite,
15 x 36½ (38.1 x 92.7)
Currier Funds 1950.2

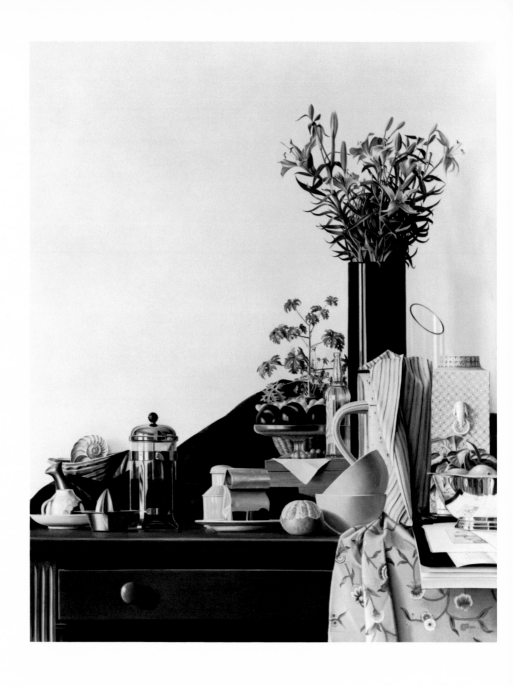

JAMES APONOVICH (b. 1948)
Still Life with Flowers, 1984
Oil on canvas, 60 x 48 (152.4 x 121.9)
Gift of the Friends 1985.2

TOM BLACKWELL (b. 1938)
Hudson River Landscape, 1984
Oil on canvas, 50¾ x 119¾ (128.9 x 304.2)
Gift of Janet Hulings Bleicken, Robert P.
Bass, Jr., Eleanor Briggs, Edith and Peter
Milton, Charles and Mary Merrill and the
Rosmond deKalb Fund 1987.13

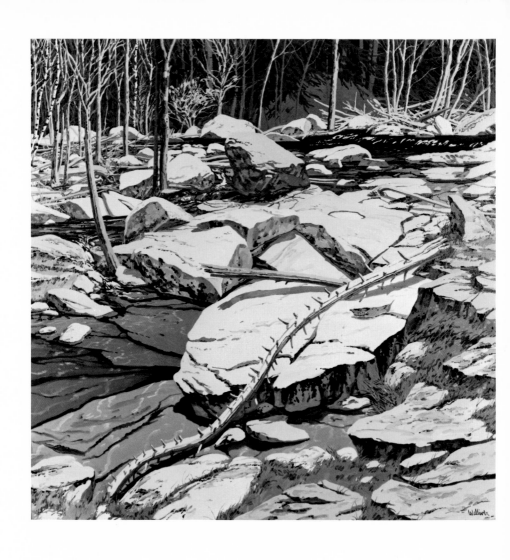

NEIL WELLIVER (b. 1929)
Blue Pool, 1980
Oil on canvas, 96 x 96 (243.8 x 243.8)
Gift of the Friends with the aid of the
National Endowment for the Arts
1980.87

GREGORY AMENOFF (b. 1948)
Down by the Pylons, 1980
Oil on canvas, 60 x 72 (152.4 x 182.9)
Rosmond deKalb Fund with the aid of the
National Endowment for the Arts
1980.59

American Sculpture

UNKNOWN ARTIST
Molasses Merchant's Sign, c. 1850
Painted wood,
38¼ x 21¼ x 13⅞ (96.8 x 54.0 x 35.2)
Contribution Box Funds 1978.21

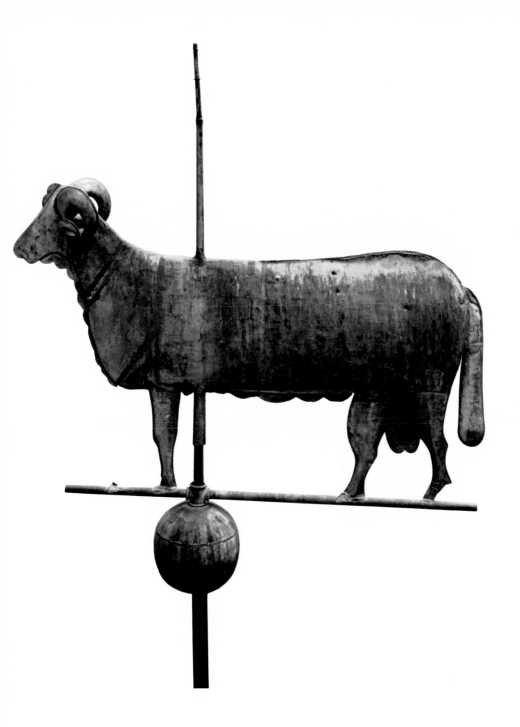

UNKNOWN ARTIST
Weathervane, c. 1855
Copper with traces of gold leaf, 81 x 73 x 11
(205.7 x 185.4 x 27.9), ball to spike
Gift of Dr. and Mrs. Michael A. Michaels
1961.4

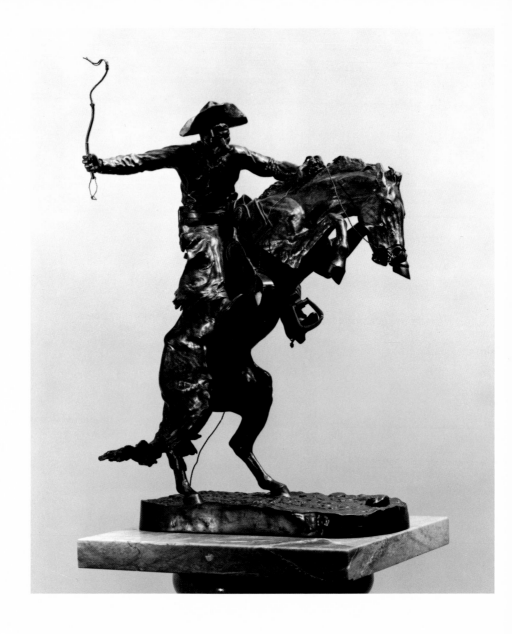

FREDERIC SACKRIDER REMINGTON
(1861–1909)
The Bronco Buster, 1895
Bronze, 25½ x 19 x 13 (64.8 x 48.3 x 33.0)
Bequest of Florence Andrews Todd
1937 T31 (169)

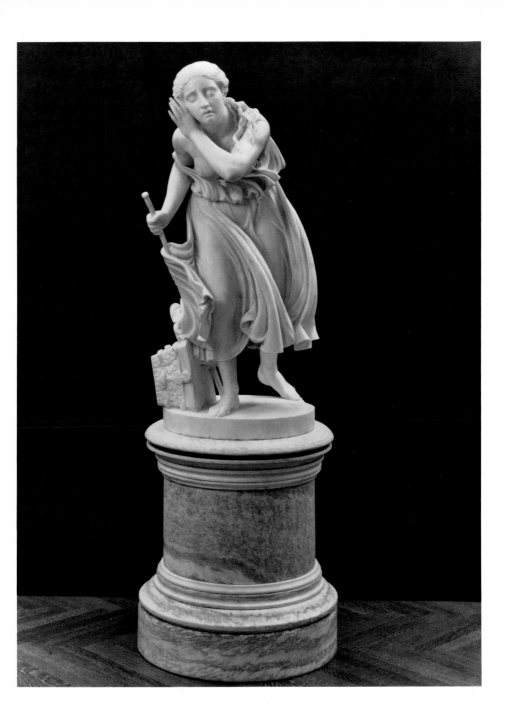

RANDOLPH ROGERS (1825–1892)
Nydia, The Blind Girl of Pompeii, 1863
Marble, 54 x 26½ x 37 (137.2 x 67.3 x 94.0)
Henry Melville Fuller Fund 1989.3

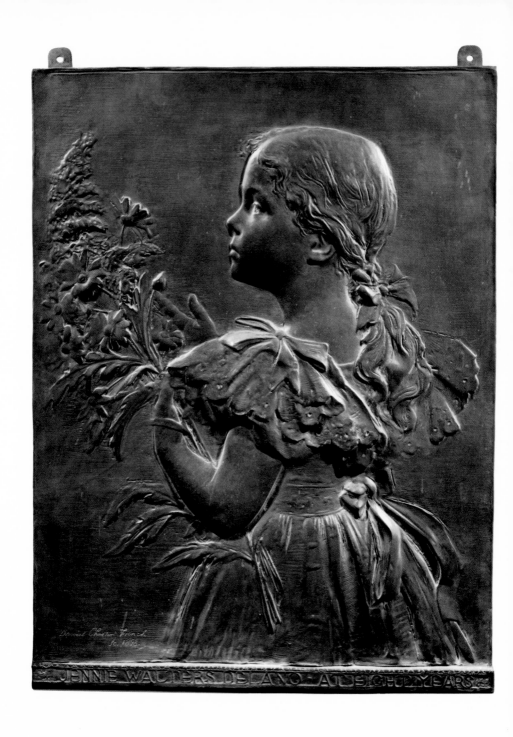

DANIEL CHESTER FRENCH (1850–1931)
Jenny Walters Delano at Eight Years, 1898
Bronze relief, 24½ x 18½ (62.2 x 47.0)
Anonymous gift 1972.27

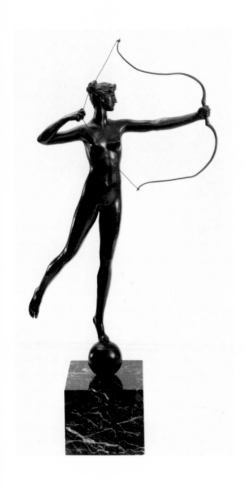

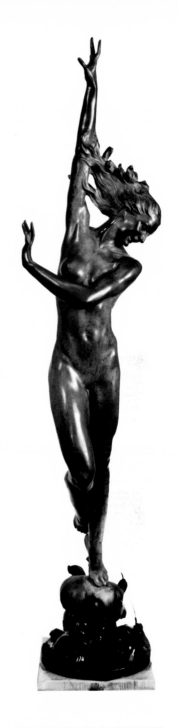

AUGUSTUS SAINT-GAUDENS (1836–1907)
Diana, c. 1892
Bronze, 32¾ x 16½ x 6½ (83.2 x 41.9 x 16.5)
Bequest of Mrs. Philip H. Faulkner
1977.55

HARRIET WHITNEY FRISHMUTH
(1880–1980)
The Crest of the Wave, c. 1929
Bronze,
65½ x 14½ x 18 (166.4 x 36.8 x 45.7)
Currier Funds 1929.2

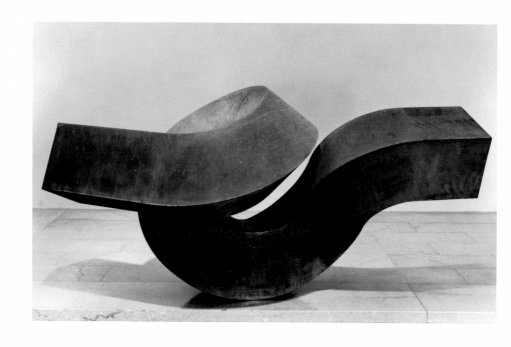

CLEMENT MEADMORE (b. 1929)
Dervish, 1972
Cor-ten steel,
25 x 52 x 26 (63.5 x 132.1 x 66.1)
Gift of Dr. Isadore J. and
Lucille Zimmerman in memory of
Samuel Zimmerman 1973.34

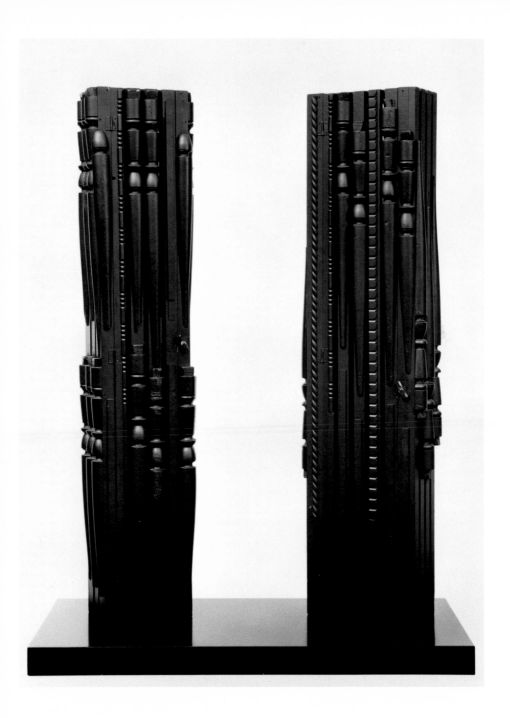

LOUISE NEVELSON (1900–1988)
Dream Houses XXXIII, 1972
Painted wood,
63 x 48 x 24 (160.0 x 121.9 x 61.0)
Currier Funds with the aid of the National
Endowment for the Arts 1973.33

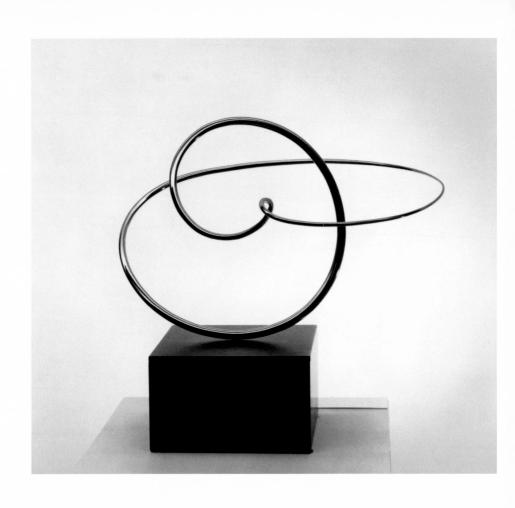

JOSÉ DE RIVERA (1904–1985)
Construction No. 195, 1982
Stainless steel, 20⁷⁄₁₆ x 21 x 21
(51.9 x 53.3 x 53.3) including base
Gift of Grace Borgenicht 1986.3

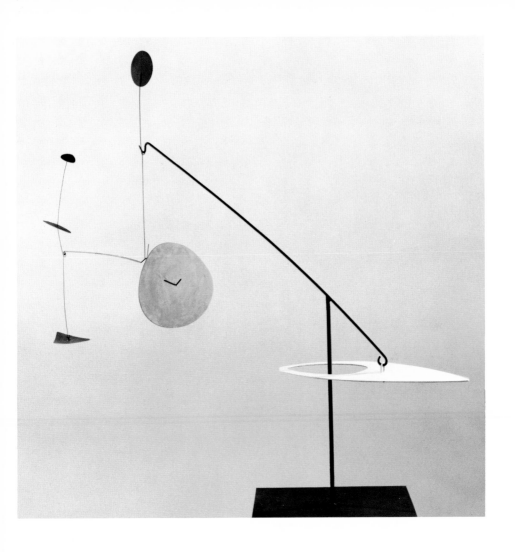

ALEXANDER CALDER (1898–1976)
Little Yellow Disk, 1967
Painted steel, 92 x 116 (233.7 x 294.6)
Gift of the Friends in honor of their
25th anniversary 1983.82

Works on Paper

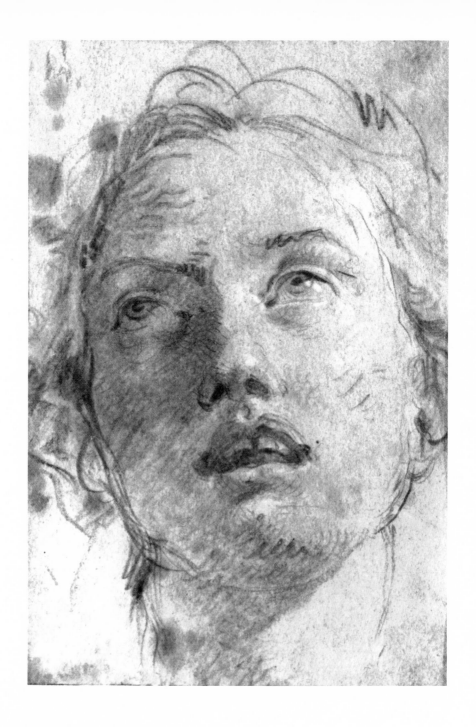

GIOVANNI-BATTISTA TIEPOLO
(1696–1770), Italian
Head of St. Agathe, c. 1740–50
Red crayon, 9⅞ x 6½ (25.1 x 16.5)
Gift of Mr. and Mrs. Samuel Gruber
1973.81

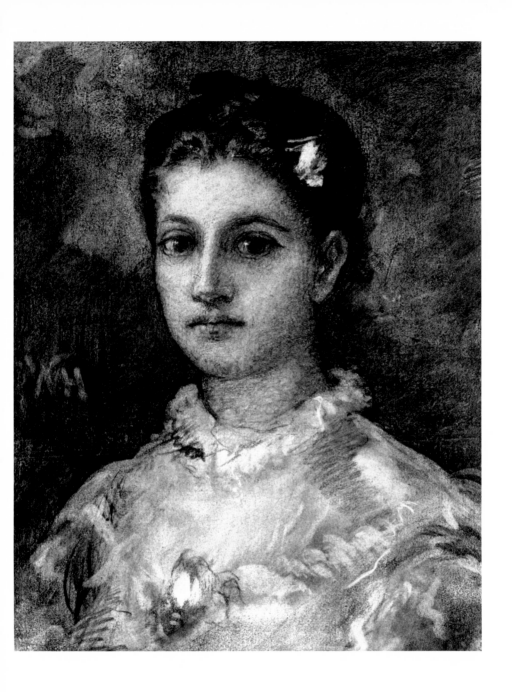

WILLIAM MORRIS HUNT (1824–1879),
American
Portrait of a Young Girl, c. 1875
Charcoal, 20 x 15¾ (50.8 x 40.0)
Gift of T. Gilbert Brouillette 1941.8

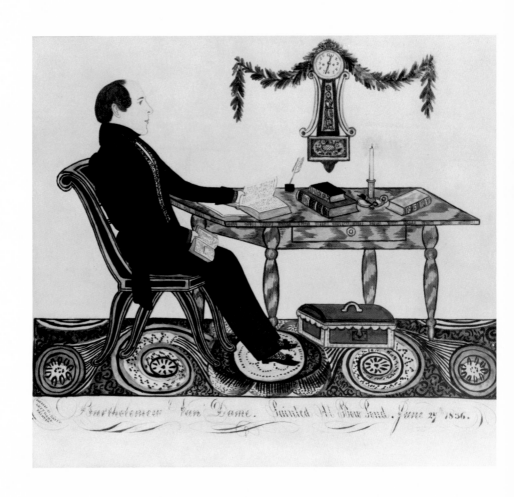

JOSEPH H. DAVIS (active 1832–37),
American
Bartholomew Van Dame, 1836
Ink and watercolor, 10 x 11¼ (25.4 x 28.6)
Purchased in honor of Melvin E. Watts
1981.15

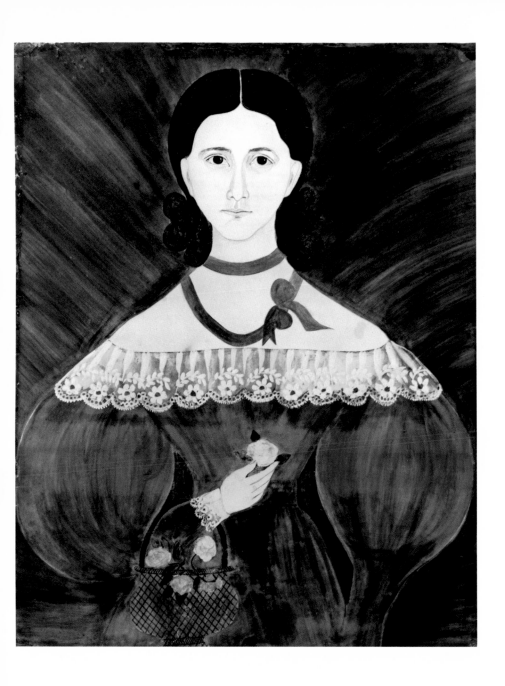

ATTRIBUTED TO RUTH W. SHUTE
(1803–1882) and SAMUEL A. SHUTE
(1803–1836), American, (Milford,
New Hampshire)
Portrait of a Lady, c. 1825
Watercolor, 24 x 19 (61.0 x 48.3)
Currier Funds 1932.1.135

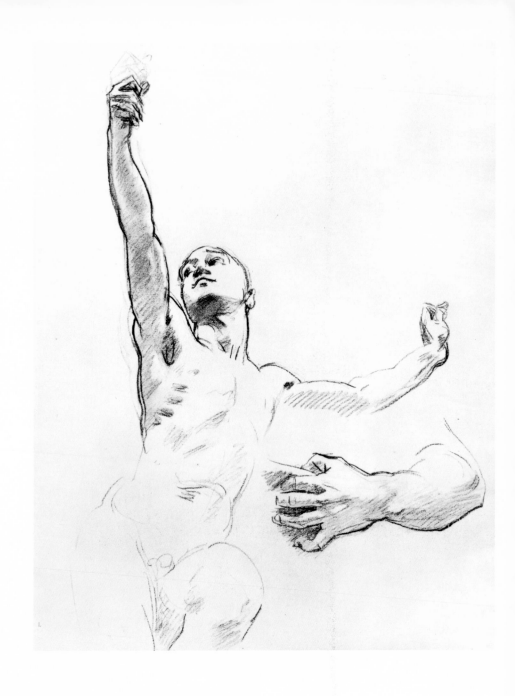

JOHN SINGER SARGENT (1856–1921),
American
Figure Study, c. 1920
Charcoal, 24¼ x 18 (61.6 x 45.7)
Bequest of Miss Emily Sargent, London,
England 1939.7.1

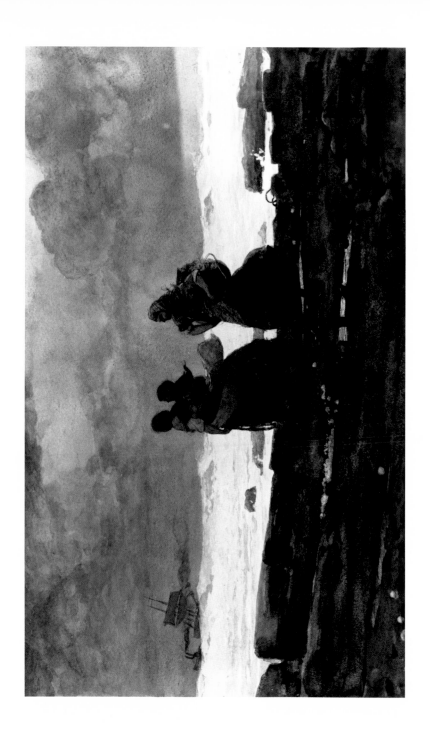

WINSLOW HOMER (1836–1910), American
Fishwives, 1883
Watercolor, 18¼ x 29½ (46.4 x 74.9)
Currier Funds 1938.1

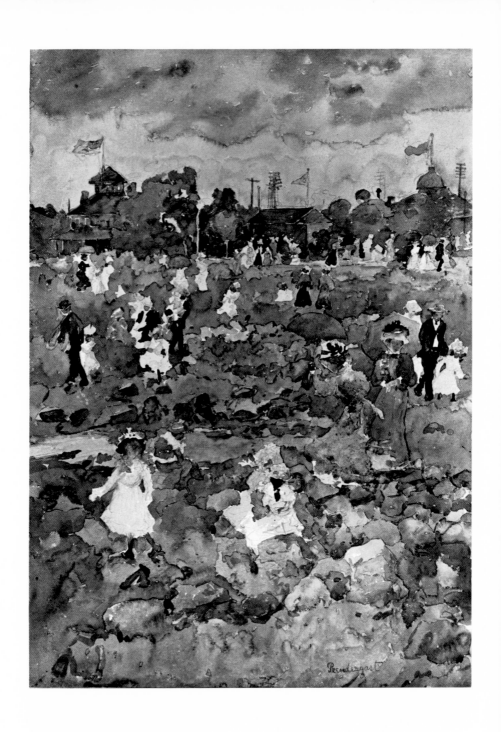

MAURICE BRAZIL PRENDERGAST
(1858–1924), American
The Stony Pasture, 1895
Watercolor, 19 x 13⅞ (48.3 x 35.2)
George A. Leighton and Mabel Putney
Folsom Funds 1959.6

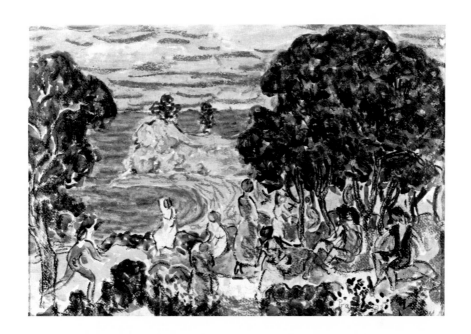

MAURICE BRAZIL PRENDERGAST
(1858–1924), American
Figures by the Shore, 1915
Watercolor and pastel, 15 x 22 (38.1 x 55.9)
Gift of Mrs. Eleanor Briggs 1977.1

FREDERICK CHILDE HASSAM (1859–1935),
American
Newfields, New Hampshire, 1906
Watercolor, 13⅞ x 19⅞ (35.2 x 50.5)
Currier Funds 1963.1

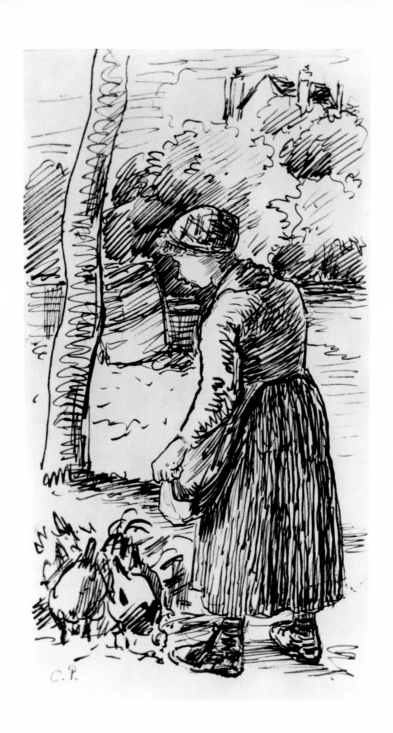

CAMILLE PISSARRO (1830–1903), French
Peasant Girl Feeding Hens
Ink, 8½ x 4½ (21.6 x 11.4)
Gift of Mr. and Mrs. Otto Gerson 1961.13

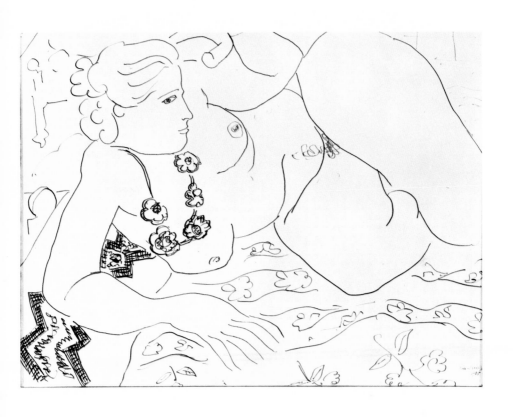

HENRI MATISSE (1869–1954), French
Reclining Nude, 1935
Ink, 17⅛ x 19½ (43.5 x 49.5)
Gift of Mr. and Mrs. Otto Gerson 1961.12

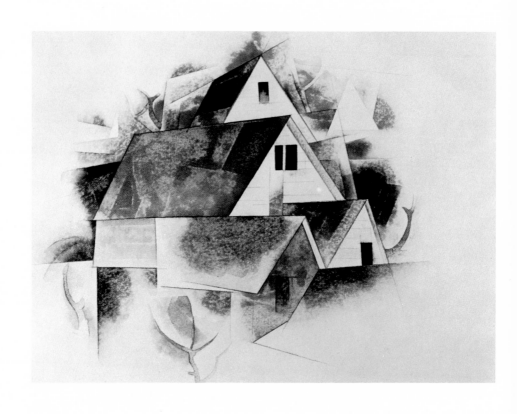

CHARLES DEMUTH (1883–1935), American
Roofs and Gables, c. 1918
Watercolor, 9½ x 13 (24.1 x 33.0)
Mabel Putney Folsom Fund 1960.22

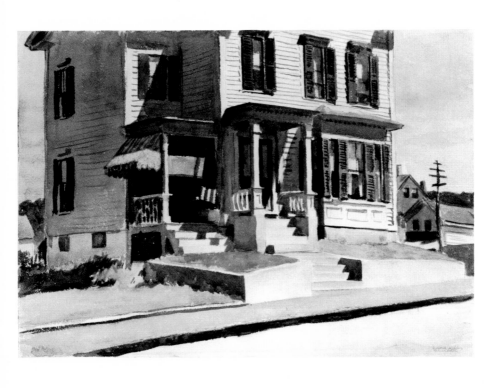

EDWARD HOPPER (1882–1967), American
House on Middle Street, Gloucester, 1924
Watercolor, 14 x 20 (35.6 x 50.8)
Gift of the Friends 1962.14

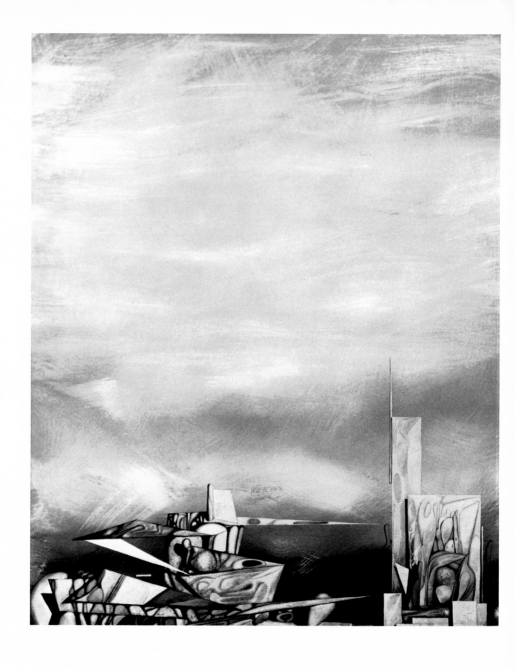

YVES TANGUY (1900–1955), French
Mira, 1952
Gouache, 29⅜ x 24 (74.6 x 61.0)
Gift of the Estate of Kay Sage Tanguy
1963.7

CHARLES E. BURCHFIELD (1893–1967),
American
November Sunset, 1950–64
Watercolor, 39⅛ x 53¼ (99.4 x 135.2)
Currier Funds 1967.10

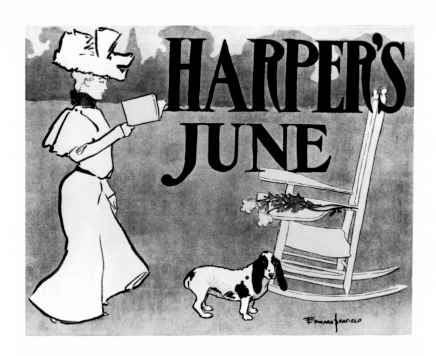

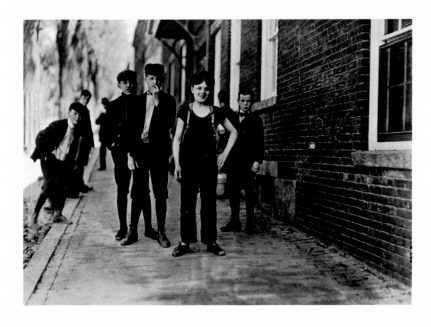

EDWARD PENFIELD (1866–1925), American
Poster for Harpers, June 1897
Lithograph, 14 x 18½ (35.6 x 47.0)
Alonzo Elliott Fund 1974.19

LEWIS W. HINE (1874–1940), American
Children Who Work in the Amoskeag Mill,
1909
Gelatin silver print, 5 x 6¾ (12.7 x 17.2)
Gift of Lotte Jacobi 1978.100

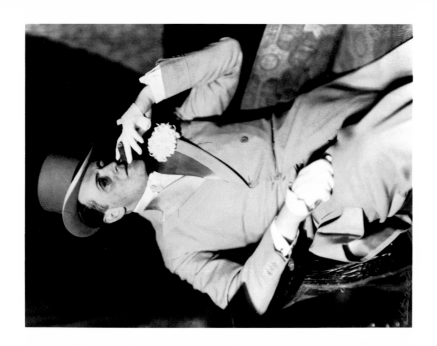

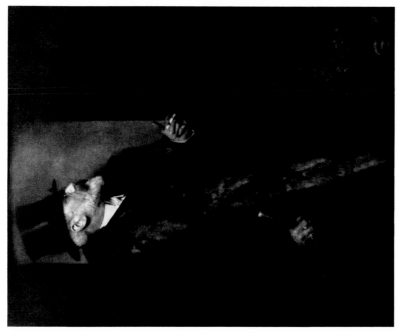

EDWARD J. STEICHEN (1879–1973),
American
William Merritt Chase, 1906
Photogravure, 8⅛ x 6½ (20.6 x 16.5)
The Vallarino Collection and Purchase Fund
1982.93

LOTTE JACOBI (b. 1896), American
Heinrich Von Twardowski, c. 1930
Silver print, 13⅞ x 10¹⁵⁄₁₆ (35.2 x 27.8)
Gift of the Friends 1985.40.38

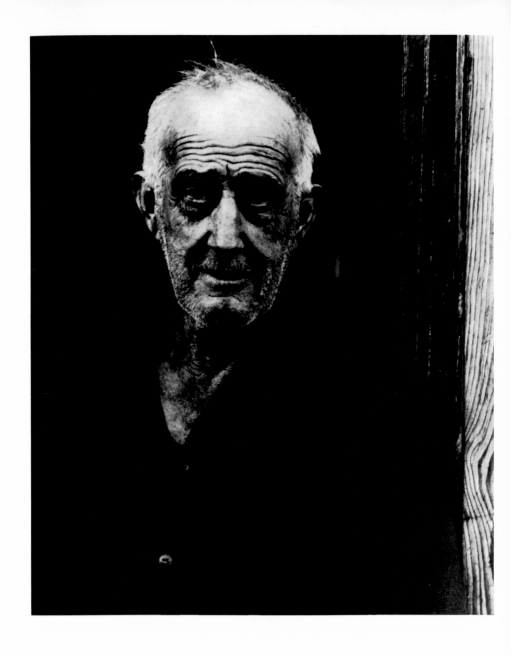

PAUL STRAND (1890–1976), American
Sawmill Worker, Dummerston, Vermont,
1946
Photograph, 10⅝ x 8⅝ (27.0 x 21.9)
Gift of The Paul Strand Foundation
1983.40

ALLEN M. D'ARCANGELO (b. 1930),
American
Untitled, 1966
Silkscreen on paper, 22⅛ x 21⅞ (56.2 x 55.6)
Gift of A. Aladar Marberger 1986.51.69

Textiles

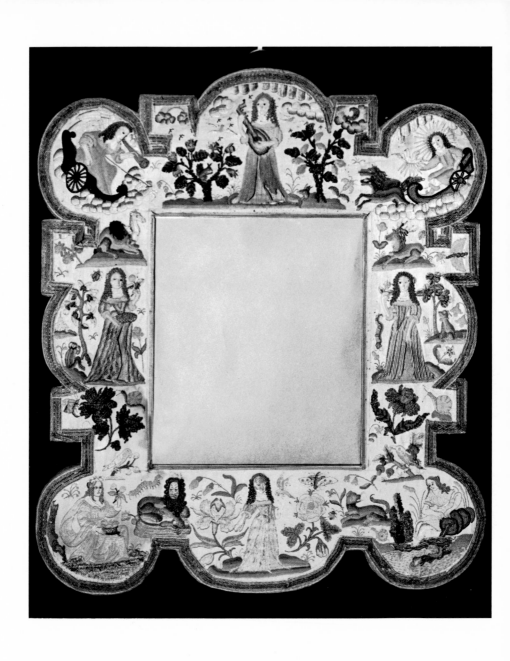

MAKER UNKNOWN, attributed to England
Mirror Frame, c. 1680
Silk embroidery, 24½ x 21 (62.2 x 53.3)
Gift of Miss Honora Spalding 1961.8

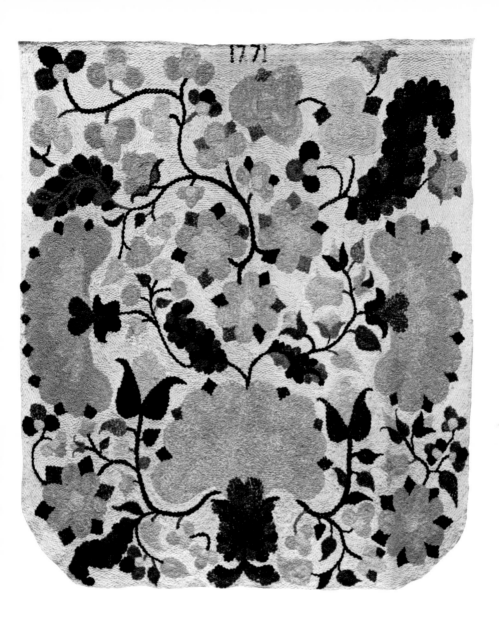

MAKER UNKNOWN, American
(attributed to Connecticut River Valley)
Bed Rug, 1771
Wool on wool embroidery,
82 x 77 (208.3 x 195.6)
Currier Funds 1932.1.144

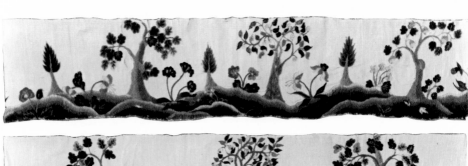

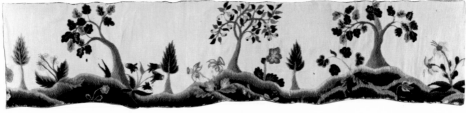

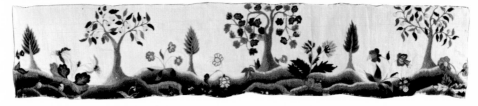

MAKER UNKNOWN, American
(attributed to New England)
Rug, c. 1800
Wool pile hooked through linen ground,
35 x 70½ (89.0 x 179.1)
Currier Funds 1932.1.107

MAKER UNKNOWN, attributed to England
Petticoat Border, c. 1740–1775
Wool on linen embroidery,
7½ x 105 (19.1 x 266.7)
Gift of Mitchell Ward 1949.2

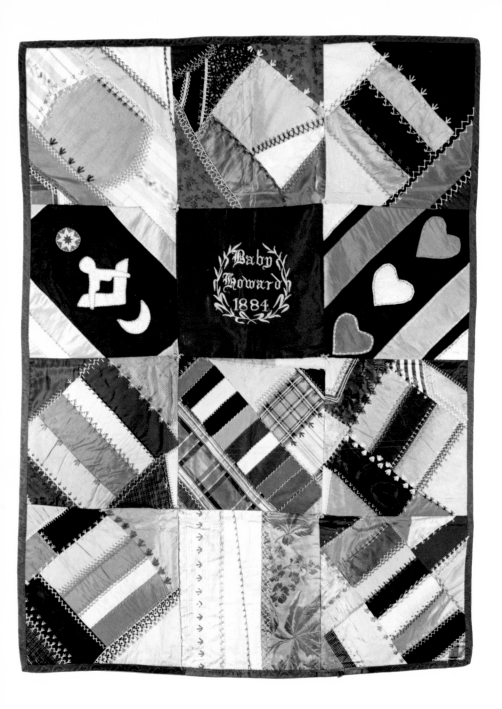

MRS. JOHN B. HOWARD (1840–1890),
American (Franklin, New Hampshire)
Quilt, 1884
Silk on silk embroidery,
74 x 46 (188.0 x 116.8)
Gift of Mrs. Melvin E. Watts 1974.4

American Furniture

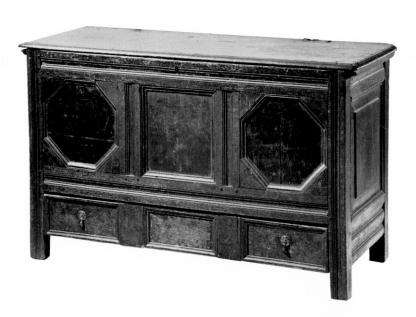

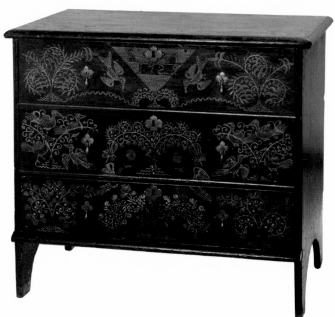

MAKER UNKNOWN, New England
Chest, 1700–1725
Oak, pine and maple, 30½ x 51¼ x 20
(77.5 x 130.2 x 50.8)
Museum purchase 1932.1.134

ROBERT CROSMAN, (1707–1799), American
(Taunton, Massachusetts)
Chest, 1729
Painted wood, 37½ x 32½ x 18
(95.3 x 82.6 x 45.7)
Gift of Marjorie Park Swope 1988.5

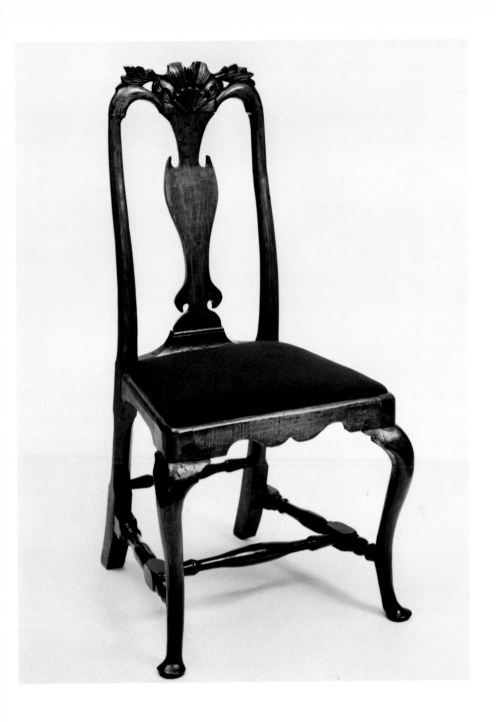

JOHN GAINES III (1704–1743)
Side Chair, c. 1732–1743
Maple with modern upholstered seat,
40½ x 21 x 19½ (102.9 x 53.3 x 49.5)
Gift of Amoskeag Bank, Bank of New Hampshire, William N. Banks Foundation,

Cogswell Benevolent Trust, Mrs. Alvah C.
Drake, Mr. Henry Melville Fuller,
Mr. Christos Papoutsy, Mrs. Lawrence W.
Shirley, and Sturm, Ruger and
Company, Inc. 1987.58

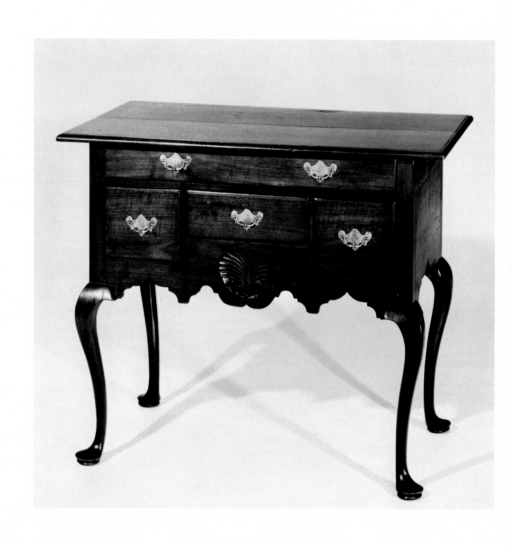

MAKER UNKNOWN,
Portsmouth, New Hampshire
Dressing Table, c. 1740
Walnut, 29 x 34⅞ x 21½ (73.7 x 88.6 x 54.6)
Bequest of Miss Elizabeth Frost 1966.2

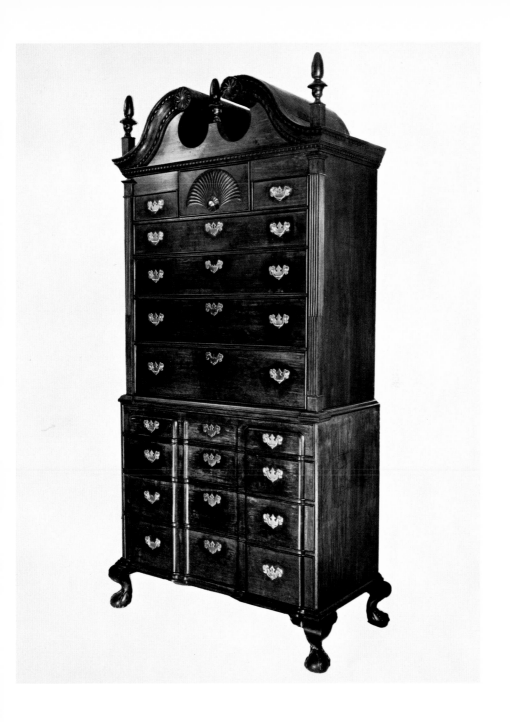

MAKER UNKNOWN, attributed to
New Hampshire
Chest-on-chest, c. 1780
Maple, 89 x 40⅝ x 19⅞
(226.1 x 103.2 x 50.5)
George A. Leighton Fund 1960.7

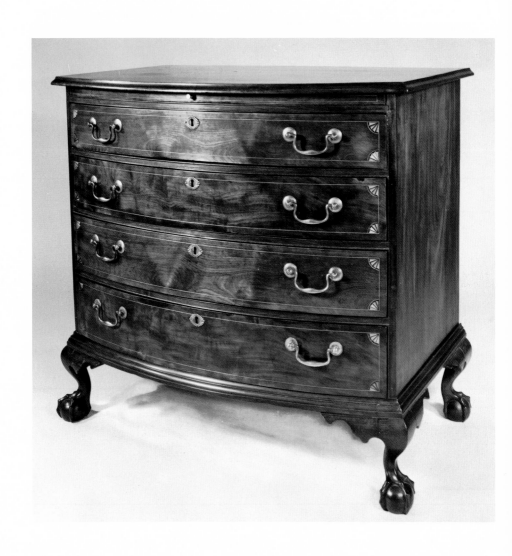

MAKER UNKNOWN, attributed to
New Hampshire, possibly Portsmouth
Chest, c. 1780
Mahogany with satinwood inlay,
34½ x 38 x 23 (87.6 x 96.5 x 58.4)
Gift of the Friends 1960.17

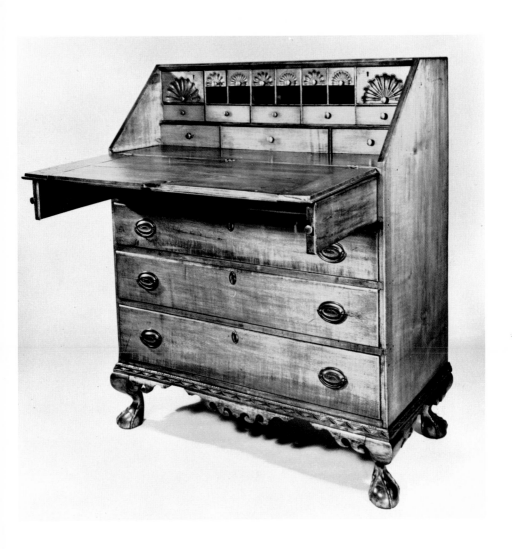

ATTRIBUTED TO THE DUNLAP FAMILY,
Bedford, Goffstown, Henniker, or
Salisbury, New Hampshire
Desk, c. 1785
Maple, 45⅜ x 38 x 19¾
(115.3 x 96.5 x 50.2)
Gift of Mrs. Winfield Shaw 1962.15

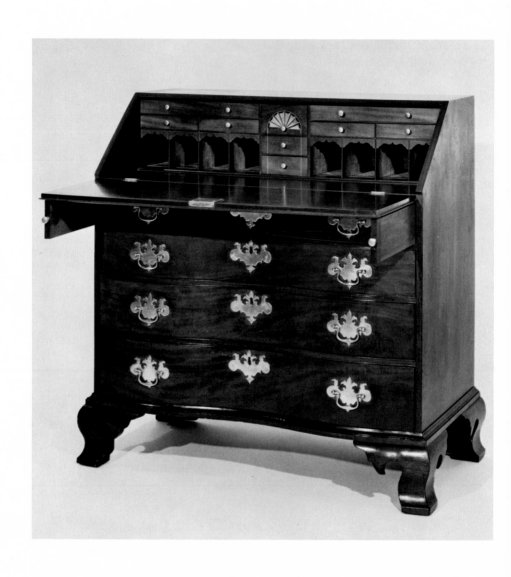

MAJOR BENJAMIN FROTHINGHAM
(1734–1809), Charlestown, Massachusetts
Desk, c. 1780
Mahogany, 43⅛ x 43¾ x 22⅞
(109.5 x 111.1 x 58.1)
Gift of Mrs. Norwin S. Bean 1967.2

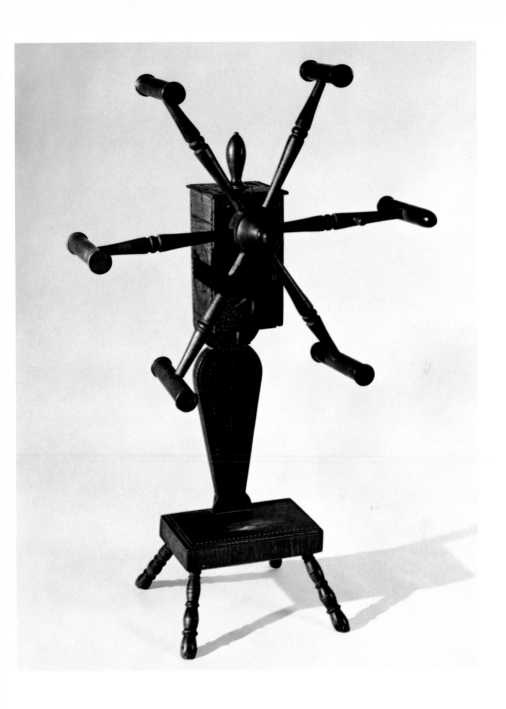

MAKER UNKNOWN
Yarn Winder, 1789
Curly maple with chip carving,
40 x 24¼ x 13¼ (101.6 x 61.6 x 33.7)
Currier Funds 1952.1

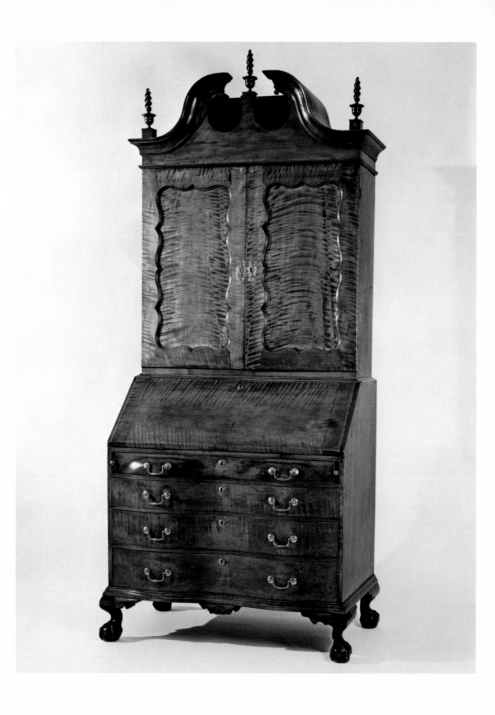

MAKER UNKNOWN, attributed to central
New Hampshire
Secretary Desk, 1799
White pine and curly maple,
100⅛ x 42¼ x 23 (254.3 x 107.3 x 58.4)
Currier Funds 1958.6

162

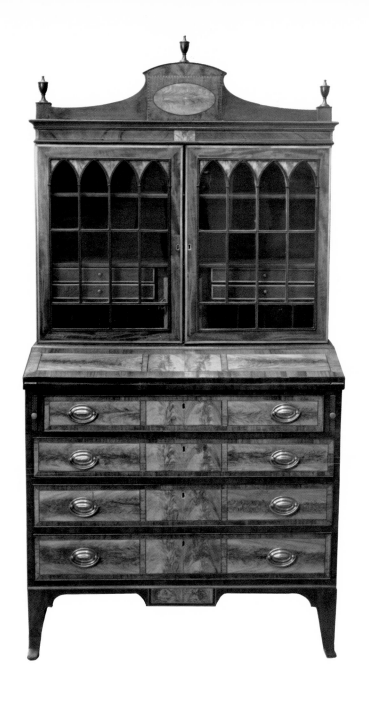

ATTRIBUTED TO JONATHAN JUDKINS and
WILLIAM SENTER (active 1809–1826),
Portsmouth, New Hampshire
Secretary Desk
Mahogany and branch satinwood,
76 x 39 x 19¾ (193.0 x 99.1 x 50.2)
Gift of the Friends 1974.24

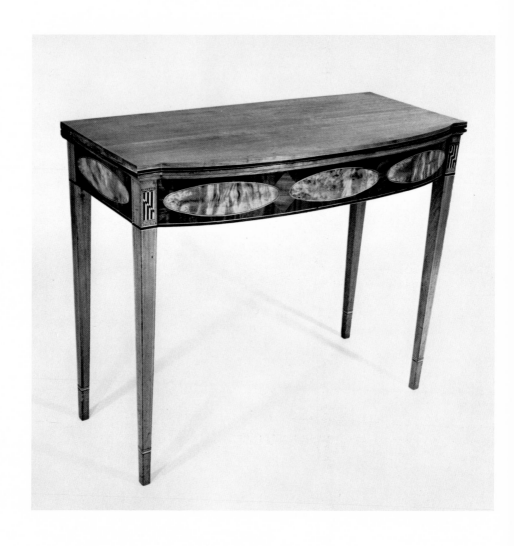

MAKER UNKNOWN, attributed to
New Hampshire
Card Table, c. 1800
Cherry and mahogany with satinwood veneer,
27½ x 35¼ x 16½ (69.9 x 89.5 x 41.9)
Currier Funds 1932.1.104.1

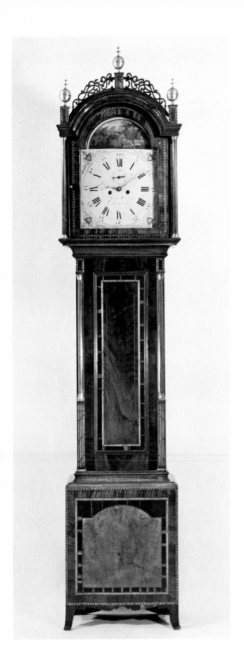

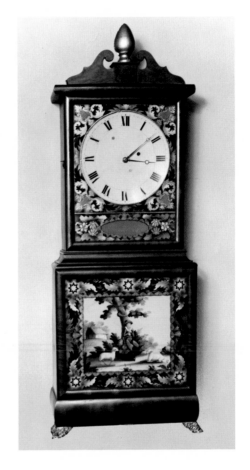

Movement by LEVI HUTCHINS
(1761–1855), Concord, New Hampshire.
Case by UNKNOWN MAKER, probably
Concord, New Hampshire
Tall Clock, c. 1807
Curly maple, bird's-eye maple, rosewood and
satinwood, 99¾ x 19⅞ x 9½
(253.4 x 50.5 x 24.1)
Currier Funds 1962.1

Movement by LEVI HUTCHINS
(1761–1855), Concord, New Hampshire.
Case by UNKNOWN MAKER, probably
New Hampshire
Shelf Clock, c. 1830
Mahogany veneer with reverse painted glass
panels, gilded wood finial, and white-
enamel-painted iron dial,
34⅝ x 12⅞ x 5⅞ (88.0 x 32.7 x 14.9)
Gift of Mr. and Mrs. Paul E. Sargeant in
memory of Frank W. Sargeant 1973.67

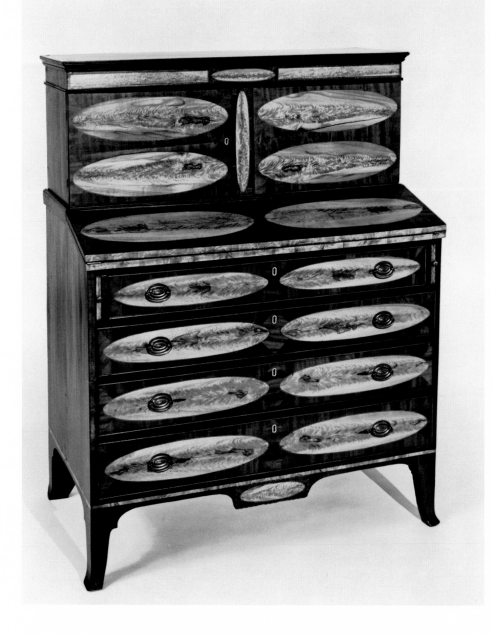

MAKER UNKNOWN, attributed to
southeastern New Hampshire
Secretary Desk, c. 1810
Mahogany with satinwood veneer and
mahogany cross-banding,
53½ x 42⅞ x 20¾ (135.9 x 108.9 x 52.7)
Gift of the Friends 1971.26

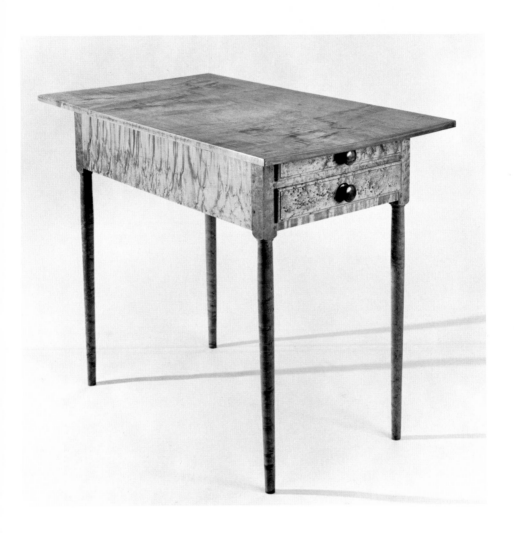

MAKER UNKNOWN, attributed to Shaker
Colony, Canterbury, New Hampshire
Sewing Table, c. 1825
Maple and pine, 25¾ x 32⅛ x 18⅝
(65.4 x 81.6 x 47.3)
Currier Funds 1970.2

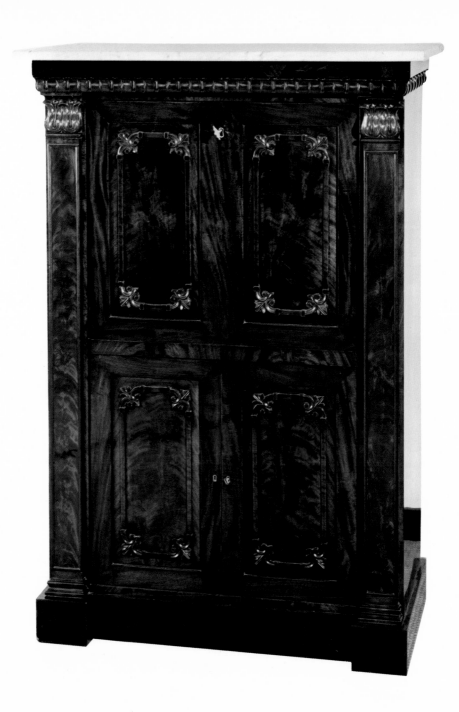

MAKER UNKNOWN, Boston, Massachusetts
Secretary Desk, 1820
Mahogany, mahogany veneer, white
marble and white pine, 60 x 36 x 20
(152.4 x 91.4 x 50.8)
Gift of the Friends 1986.16

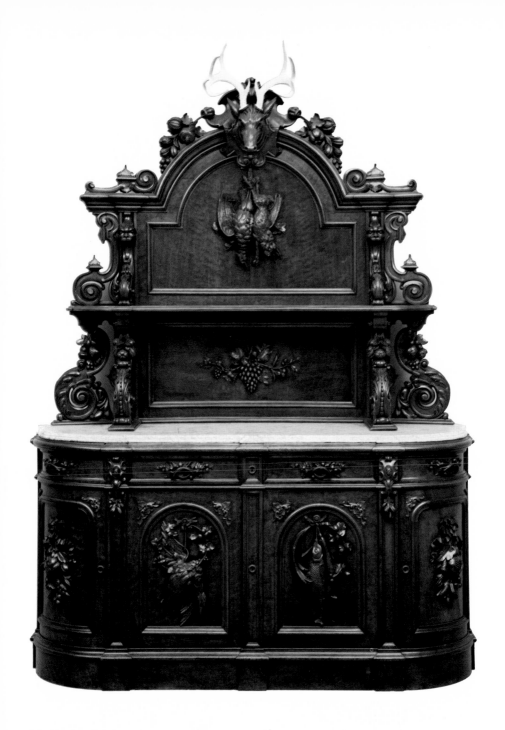

MAKER UNKNOWN,
possibly Boston, Massachusetts
Sideboard, c. 1855
Walnut, walnut burl veneer and marble,
92 x 73½ x 25¾ (233.7 x 186.7 x 65.4)
Gift of Mrs. Frances MacKay 1981.56

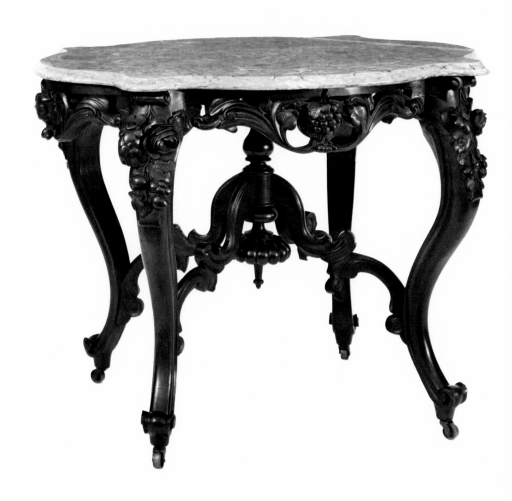

BUCKLEY AND BANCROFT,
Boston, Massachusetts
Center Table, c. 1860
Marble and walnut, 30⅜ x 39½ x 30
(77.2 x 100.3 x 76.2)
Gift of the Friends 1982.1

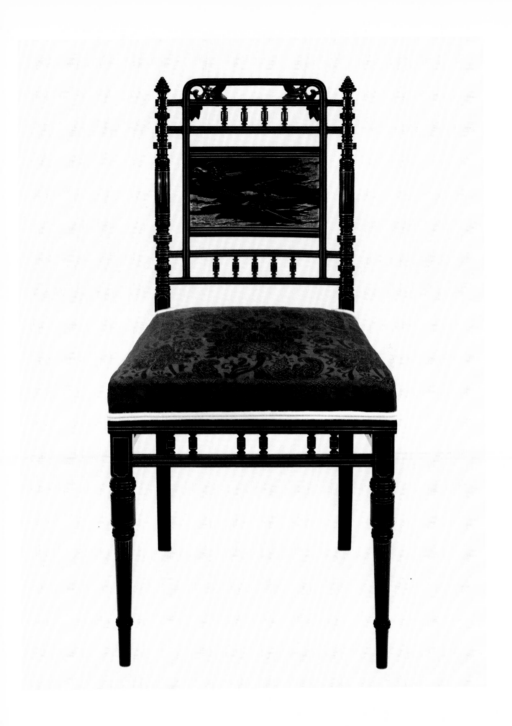

HERTER BROTHERS, New York, New York
Attributed to Christian Herter (1840–1883)
German (active in America 1860–1883)
Side Chair, c. 1880
Ebonized cherry and oak,

34 x 17⅜ x 18¾ (86.4 x 44.1 x 47.6)
Currier Funds and gift in memory of
Dr. and Mrs. Daniel Capron Norton from
Dr. and Mrs. Russell C. Norton 1981.80

Silver

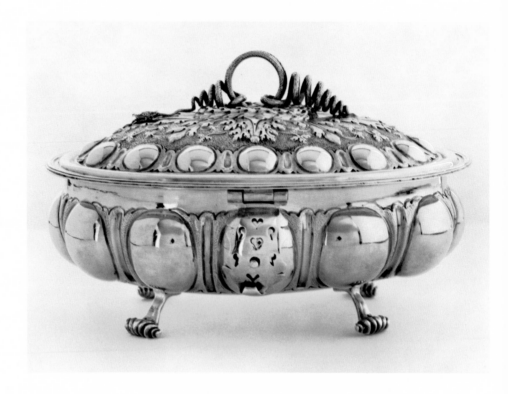

JOHN CONEY (1655–1722), American
Sugar Box, c. 1680
Marked: IC, 5½ x 8⅜ x 7 (14.0 x 21.3 x 17.8)
Given in memory of H. Ellis Straw by
his wife 1955.1

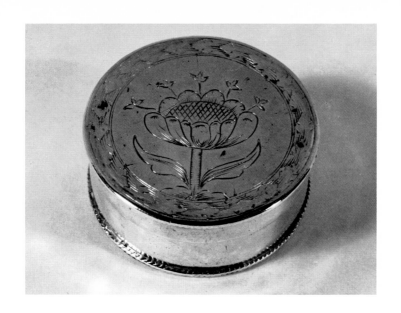

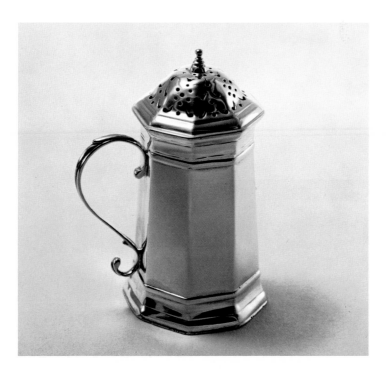

WILLIAM COWELL (1682/83–1736),
American
Patch Box, 1712
Marked: WC, Inscribed: Hannah Bray 1712,
¹¹⁄₁₆ x 1 ⅝ (1.7 x 4.1)
Currier Funds 1948.7

JACOB HURD (1702–1758), American
Spice Dredger, c. 1727
Marked: I HURD, Inscribed: IKD,
3 ⅝ x 2 x 1 ¹⁵⁄₁₆ (9.1 x 5.1 x 4.9)
Currier Funds 1948 PCG 16(69)

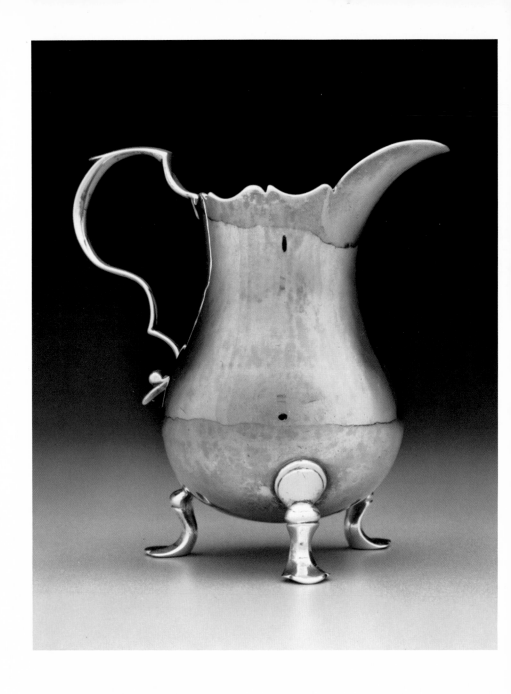

PAUL REVERE I (1702–1754), American
Cream Pot, c. 1750
Marked: PR, Inscribed: BAH,
3⅞ x 4 x 2½ (9.8 x 10.2 x 6.4)
Currier Funds 1948.12

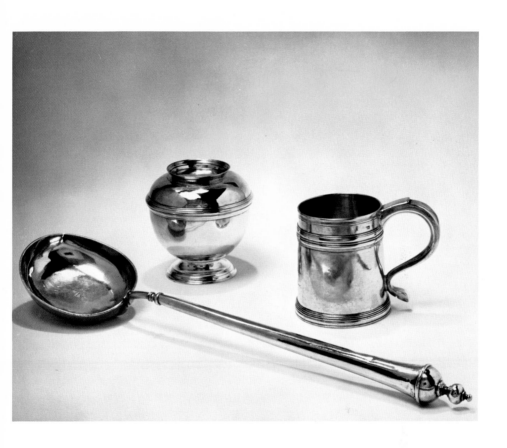

WILLIAM HOMES (1717–1783), American
Sugar Bowl and Cover, c. 1735
Marked: Homes, Inscribed: J. Tyler,
4 x 4¹/₁₆ (10.2 x 10.3)
Currier Funds 1948.11

EDWARD WEBB (1655–1718), American
Cann, c. 1700
Marked: EW, Inscribed: IBG,
3⅞ x 5⅛ x 3⅜ (8.8 x 13.3 x 8.3)
Currier Funds 1948.9

EDWARD WINSLOW (1669–1753), American
Basting Spoon, c. 1690
Marked: EW, Inscribed: ECI,
17¼ x 3⅝ x 2⅛ (43.8 x 9.2 x 5.4)
Currier Funds 1948.8

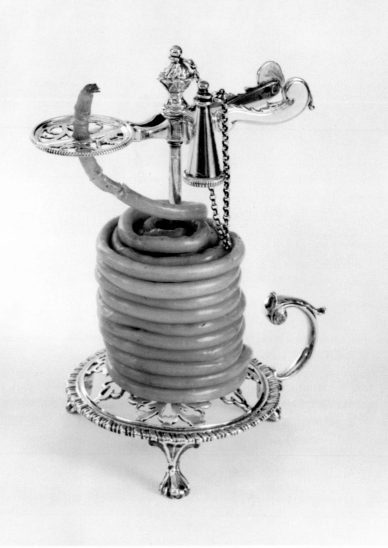

JOHN LANGFORD and JOHN SEBILLE,
(active mid-18th century) English
Wax Jack, c. 1764–65
6¼ x 5 x 3⅜ (15.9 x 12.7 x 8.6)
Gift of Mr. and Mrs. Foster Stearns 1950

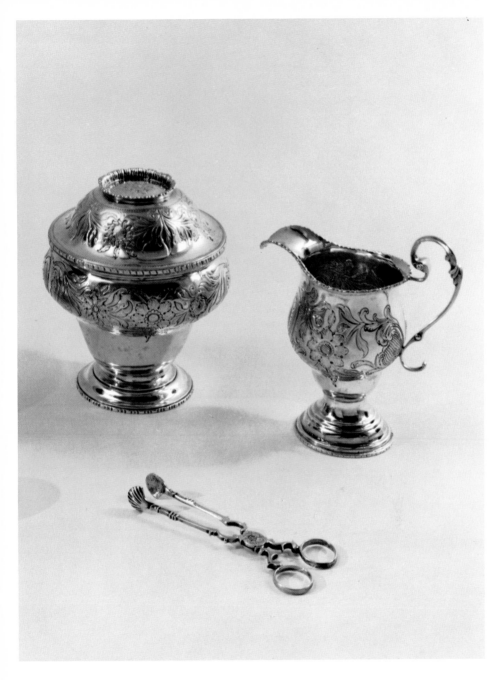

WILLIAM W. GILBERT (1746–1818),
American
Cream Pot and Sugar Bowl, c. 1770
Inscribed: LVK, Cream pot 5⅛ x 4¾ x 2¾
(13.0 x 12.1 x 7.0); sugar bowl with cover
5¼ x 4½ (13.3 x 11.4)
Gift of Misses Laura E. and
Frances H. Dwight 1974.37 a–b

SAMUEL GRIFFETH (1729–1773), American
(Portsmouth, New Hampshire)
Sugar Tongs, c. 1760
Marked: SG, ⅝ x 4⁹⁄₁₆ x 1⅝ (1.6 x 11.6 x 4.1)
Currier Funds 1974.48

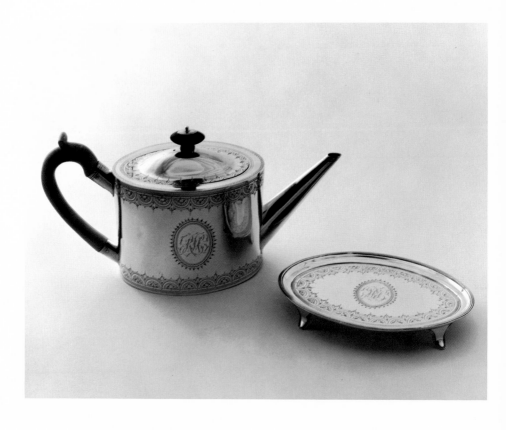

JOHN ROBINS (born mid-18th century–
1831), English
Teapot, 1792–93
5⅜ x 10½ x 3¾ (13.7 x 26.7 x 9.5)
Gift of Miss Honora Spalding on behalf of
Priscilla McKean 1961.10a

HENRY CHAWNER (1764–1851), English
Teapot Stand, 1791–92
⅞ x 6⅝ x 4¹⁄₁₆ (2.2 x 16.8 x 10.3)
Gift of Miss Honora Spalding on behalf of
Priscilla McKean 1961.10b

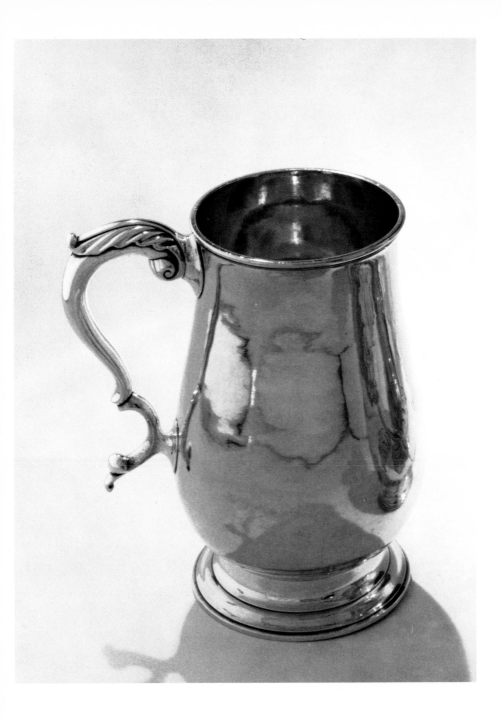

JOSEPH FOSTER (1760–1839), American
Cann
Marked: Foster,
6¾ x 3¾ x 6¼ (17.2 x 9.5 x 15.9)
Gift of Mrs. Peter Woodbury
in memory of her husband, the Honorable
Peter Woodbury 1980.26

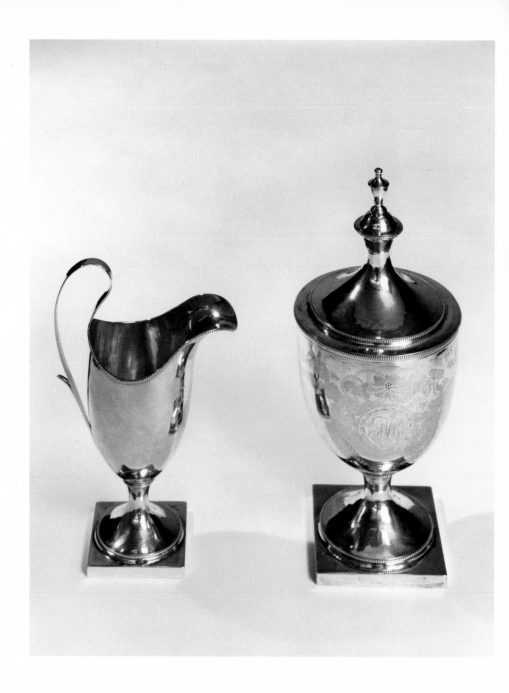

JOHN MCMULLIN (1795–1841) Philadelphia, Pennsylvania
Creampot, 1802
Marked: IM, Inscribed: MH,
7¾ x 6⅜ (19.7 x 16.2)
Gift of Mrs. P. Prime Swain in memory of her parents, Mr. and Mrs. Alfred Coxe Prime
1984.12.1

JOHN MCMULLIN (1795–1841) Philadelphia, Pennsylvania
Sugar Bowl with Cover, 1802
Marked: IM, Inscribed: MH,
10⁵⁄₁₆ x 4⅜ (26.2 x 11.1)
Gift of Mrs. P. Prime Swain in memory of her parents, Mr. and Mrs. Alfred Coxe Prime
1984.12.2

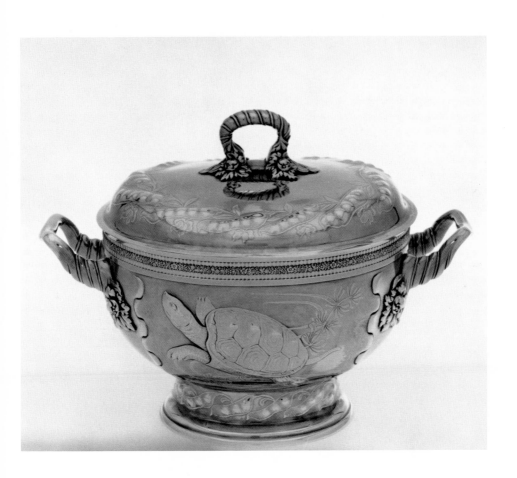

WHITING MANUFACTURING COMPANY
(1866–present) American
(North Attleboro, Massachusetts)
Soup Tureen, c. 1880
Marked: Whiting Manufacturing Company
stamp, 8 x 12 (20.3 x 30.5) with cover
Purchased in honor of Mary Shaw Shirley,
Gift of the Friends 1985.3

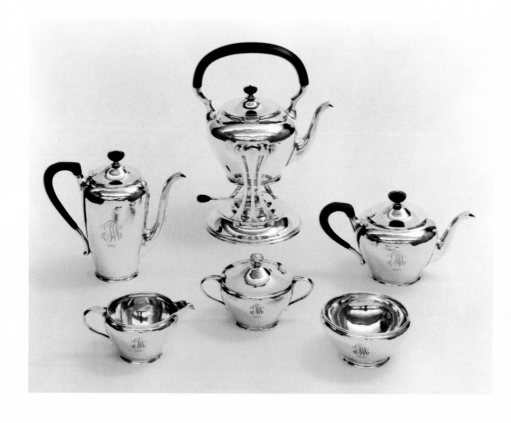

KARL F. LEINONEN (1866–1957),
American
Tea and Coffee Service, 1921
Marked: KLF, Inscribed: ETW, 1921,
Ebony handles and finials,
Hot water kettle on stand,
12⅜ x 7½ (31.0 x 18.0)

Coffee pot, 7¾ x 8½ (19.7 x 21.5)
Teapot, 5½ x 9⅜ (14.7 x 23.5)
Covered sugar, 4 x 6⅜ (10.1 x 16.3)
Creamer, 2½ x 6 (6.5 x 15.3)
Waste bowl, 2½ x 4⅞ (6.5 x 12.4)
Gift of the Friends 1988.17 a–i

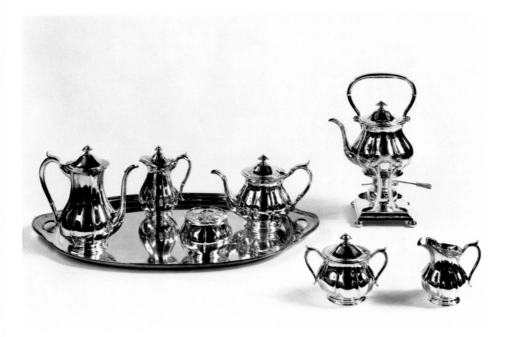

ARTHUR J. STONE (1847–1938), American
Tea and Coffee Service, c. 1920–25
Marked: A Stone Sterling, Inscribed: S E & E
1924,
Tea Tray, 1½ x 26⁵⁄₁₆ x 17 (3.8 x 66.8 x 43.2)
Teakettle with stand,
13½ x 9½ x 6⅝ (34.3 x 24.1 x 16.8)
Coffee Pot, 8¾ x 8¾ x 5 (22.2 x 22.2 x 12.7)

Teapot, 6¼ x 5½ x 9¾ (15.9 x 14.0 x 24.8)
Insulated Creamer with Hinged Lid,
6½ x 4 x 5 (16.5 x 10.2 x 12.7)
Sugar Bowl with Cover,
4⅞ x 4½ x 6½ (12.4 x 11.4 x 16.5)
Creamer, 4½ x 3¾ x 5 (11.4 x 9.5 x 12.7)
Waste Bowl, 3¼ x 4½ (8.3 x 11.4)
Gift of Mrs. Lansing Fulford 1985.44.1–8

Pewter

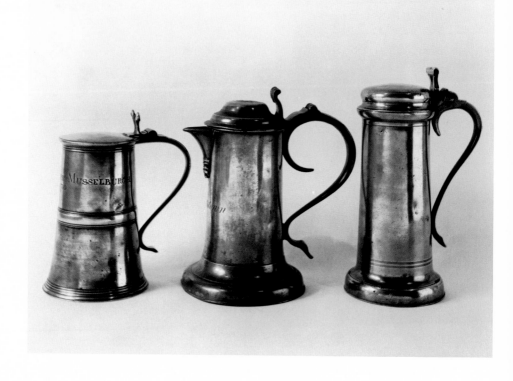

MAKER UNKNOWN, Scottish
Flagon, 1786
Marked: Eagle on globe in circle
Inscribed: Relief Kirk Musselburgh / 1786,
9¾ x 4¼ (24.8 x 10.8)
Gift of Mr. and Mrs. Winthrop L. Carter
1977.7

MAKER UNKNOWN, Irish
Flagon, 1785

Inscribed: Stewartstown,
11½ x 4¾ (29.2 x 12.1)
Gift of Mr. and Mrs. Winthrop L. Carter
1977.6.1

MAKER UNKNOWN, English
Charles I Flagon, c. 1630
Marked: E.G., 12¾ x 4½ (32.4 x 11.4)
Gift of Mr. and Mrs. Winthrop L. Carter
1977.2

188

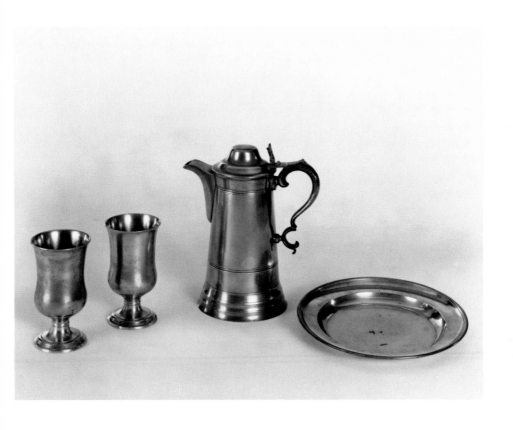

WILLIAM CALDER (1817–1856), American
(Providence, Rhode Island)
Communion Set, c. 1824
Flagon, 10¼ x 8⅞ (26.0 x 22.5)
Gift of Frederick H. Curtiss 1963.15.7
Pair of chalices, Marked: Calder,
6⅛ x 3½ (15.6 x 8.9)

Currier Funds, Howe Collection
1932.1.39.1–.2
Plate (one of a pair), Marked: Calder
1⅛ x 10⅜ (2.9 x 26.4)
Gift of Mr. Lew Sherburne Cutler
1943.1.2.1

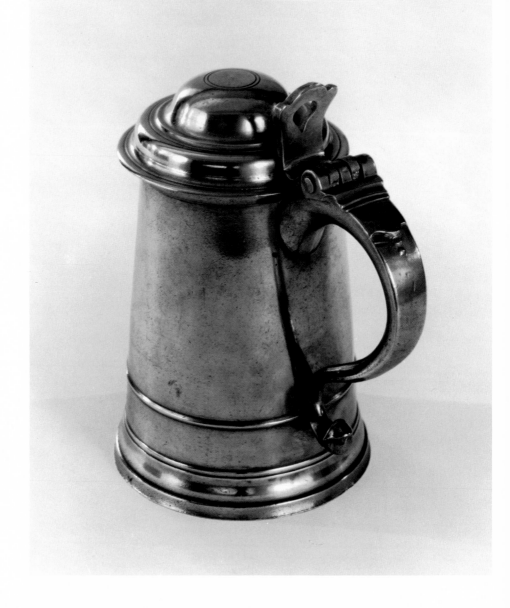

WILLIAM WILL (1764–1790), American
(Philadelphia, Pennsylvania)
Tankard, 1785
Marked: Wm. Will, Inscribed: H.G.,
7⅜ x 6½ (18.7 x 16.5)
Currier Funds, Howe Collection 1932.1.40

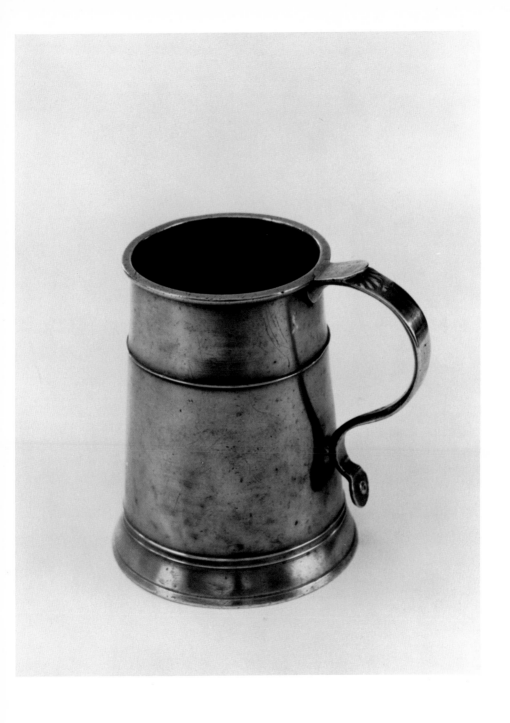

NATHANIEL AUSTIN (c. 1763–1807),
American (Charlestown, Massachusetts)
Mug, 1785
Marked: N. Austin, 5⅞ x 4¾ (14.9 x 12.1)
Currier Funds, Howe Collection 1932.1.22

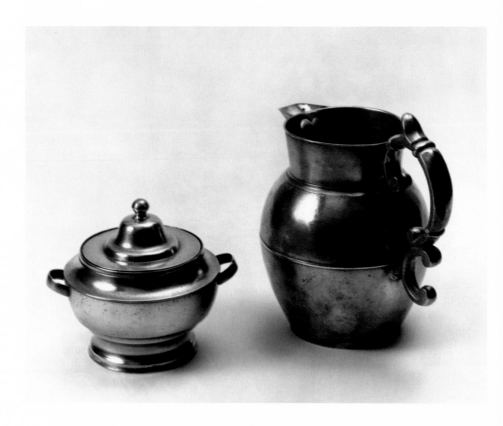

GEORGE RICHARDSON (1782–1848),
American
Lidded Sugar Bowl, 1815–30
Marked: Glenmore Co., Eagle & Cranston,
R.I., 5½ x 6⅝ (14.0 x 16.8)
Bequest of Mrs. Peter Woodbury
1980.62.4a-b

GEORGE RICHARDSON (1782–1848),
American
Pitcher, 1815–30
Marked: Glenmore Co., Eagle & Cranston,
R.I., 8½ x 9¼ (21.6 x 23.5)
Bequest of Mrs. Peter Woodbury 1980.62.5

SAMUEL HAMLIN, JR. (c. 1801–1856),
American (Providence, Rhode Island)
Church Cup, c. 1825
Marked: HAMLIN, 3¼ x 2⅜ (8.3 x 6.0)
Given in honor of Mrs. Katherine B. Palmer
1963.6

Glass

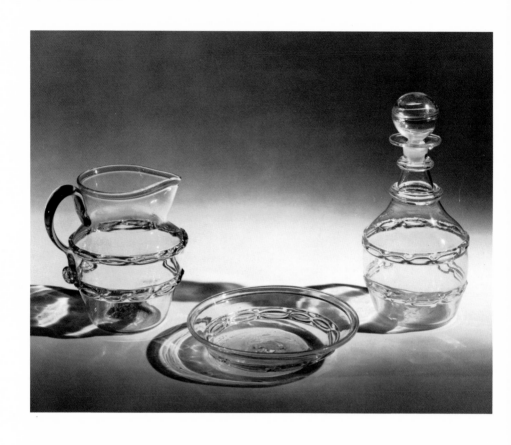

ATTRIBUTED TO THOMAS CAINS
(1779–1865), American
SOUTH BOSTON GLASS COMPANY
Pitcher, Circular Dish, and Decanter,
c. 1815
Clear blown glass with chain or guilloche
technique

Pitcher, 6⅜ x 6¾ (16.2 x 17.2)
Healey Funds 1969.15
Circular Dish, 1⅝ x 7¼ (4.1 x 18.4)
Healey Funds 1969.24
Decanter, 10 x 5⅛ (25.4 x 13.0)
Gift of Crawford Wettlaufer 1969.21

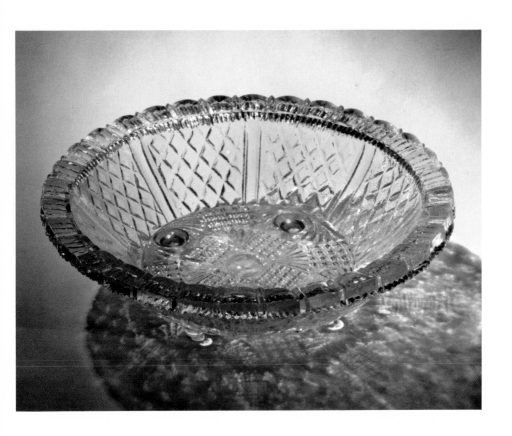

MAKER UNKNOWN, American (attributed to
New England)
Bowl, c. 1820
Clear lacy glass in strawberry diamond
pattern, 2⅝ x 9⅛ (6.7 x 23.2)
Gift of Lowell and Ethelinda Innes in mem-
ory of Ruth Graves Wakefield 1977.57

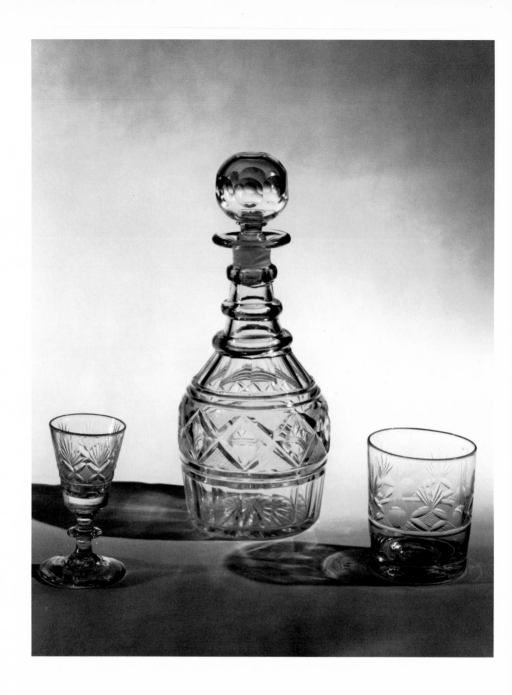

MAKER UNKNOWN, American
(attributed to Pittsburgh, Pennsylvania)
Decanter, Tumbler and Wine Glass, c. 1820
Clear cut glass,
Decanter, 11 x 4⅞ (27.9 x 12.4) 1969.16
Tumbler, 3⅜ x 3⅛ (8.6 x 7.9) 1969.23
Wine Glass, 3¹⁵⁄₁₆ x 2⁷⁄₁₆ (10.0 x 6.2) 1969.22
Healey Funds

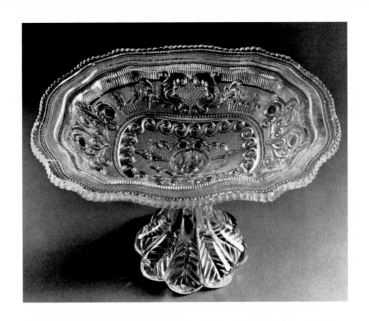

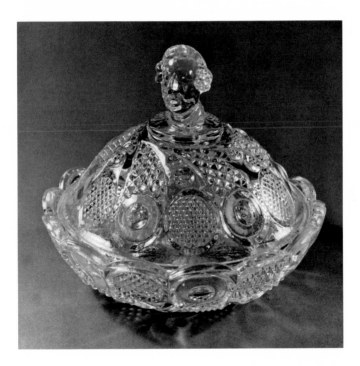

MAKER UNKNOWN, American
Vegetable Dish on Stem, c. 1830
Canary yellow lacy glass, 6⅜ x 10¾
(16.2 x 27.3)
Bequest of Richard J. Healey
1942 PCH 5 (239)

MAKER UNKNOWN, American (attributed
to Eastern United States)
Butter Dish with Washington Head Finial,
c. 1835
Canary yellow pressed glass in comet (Horn
of Plenty) pattern 5⅛ x 6⅛ (13.0 x 15.6)
Bequest of Richard J. Healey 1942 (239)

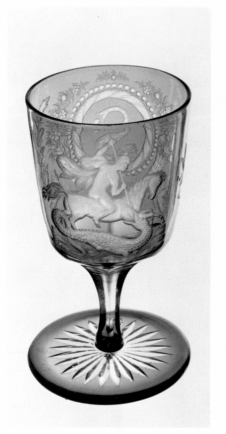

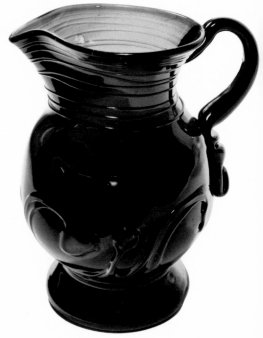

LOUIS FRIEDRICH VAUPEL (1824–1885)
engraver, German (active in America)
Goblet, c. 1875
Clear glass with flashed red overlay,
6 x 3¼ (15.2 x 8.3)
Gift of Dr. Minette Newman 1961.14.2

ATTRIBUTED TO MATTHEW JOHNSON
American
Lily Pad Pitcher, c. 1850
Blown olive amber glass, 8⅛ x 7⅝
(20.6 x 19.4)
Bequest of Richard J. Healey 1942.7

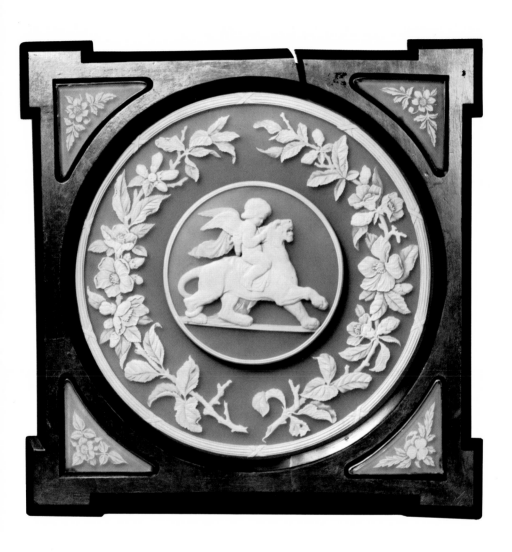

GEORGE WOODALL (1850–1925) and
THOMAS WOODALL (1849–1926)
English
Eros Riding a Lioness, c. 1885
Cameo cut glass plaque, 19¼ x 19¼
(48.4 x 48.4)
Murray Collection of Glass 1974.33.3

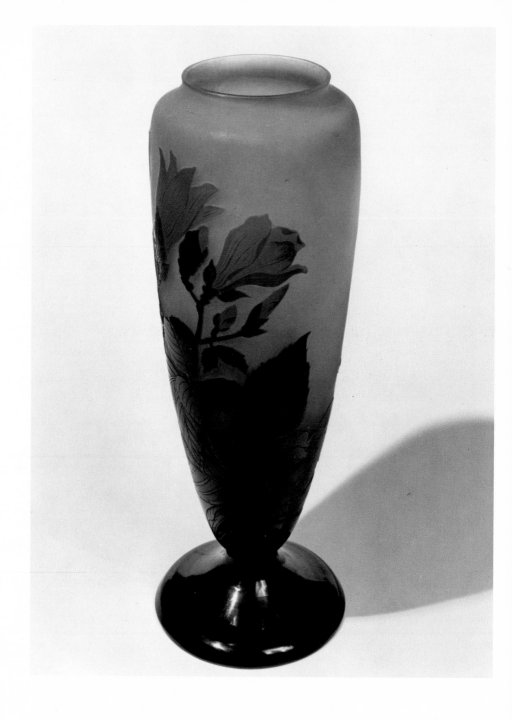

EMILE GALLÉ (1846–1905), French
Vase, c. 1890
Magnolia blossoms with leaves, 16 x 6
(40.6 x 15.2)
Gift of Mrs. Marguerite Stearns 1969.33

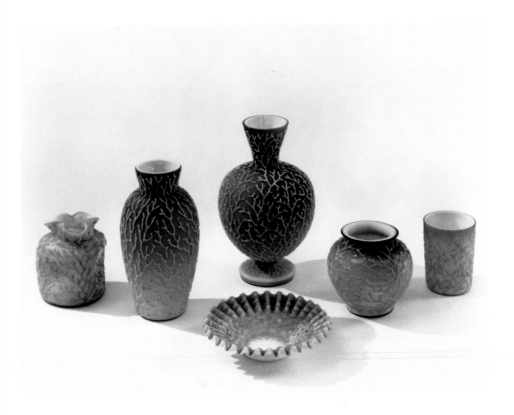

THOMAS WEBB AND SONS (active mid-
19th century to mid-20th century),
Stourbridge, England
Vase, Mother of pearl satin glass with gold
glass beads applied, 3½ x 3⅞ (8.9 x 9.8)
Camp Collection 1985.22.12

MAKER UNKNOWN
Vase, Cased glass with silver glass beads
applied, 7¼ x 4¼ (18.4 x 10.8)
Camp Collection 1985.22.9

THOMAS WEBB AND SONS (active mid-
19th century to mid-20th century),
Stourbridge, England
Tray, Mother of pearl satin glass with gold
glass beads applied, 1⅜ x 6 (3.5 x 15.2)
Camp Collection 1985.22.27

MAKER UNKNOWN
Vase, Cased glass with gold beads applied,
8½ x 7½ (21.6 x 19.1)
Camp Collection 1985.22.39

MAKER UNKNOWN
Bowl, Satin glass with gold and red glass
beads, 3⅞ x 4¼ (9.8 x 10.8)
Camp Collection 1985.22.13

MAKER UNKNOWN
Tumbler,
Satin glass with gold glass,
3½ x 2⅝ (8.9 x 6.7)
Camp Collection 1985.22.8

Isadore J. and Lucille Zimmerman House

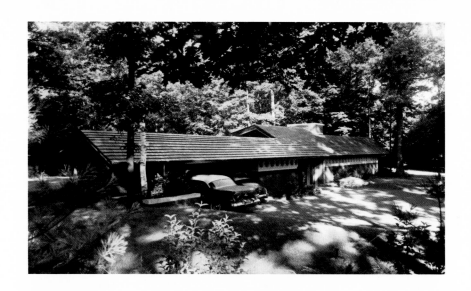

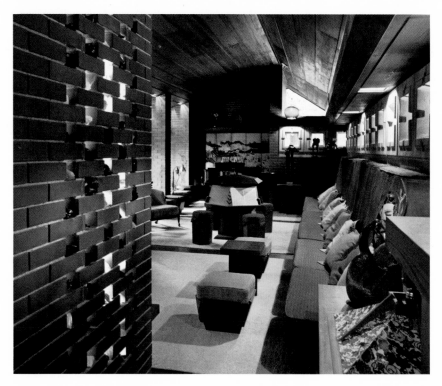

FRANK LLOYD WRIGHT (1867–1959),
American
Isadore J. and Lucille Zimmerman House,
1950
Exterior, view of front of house
1954 photograph by unknown American
photographer
Bequest of Isadore J. and Lucille Zimmerman

FRANK LLOYD WRIGHT (1867–1959),
American
Isadore J. and Lucille Zimmerman House,
1950
Interior, view toward living room
Bequest of Isadore J. and Lucille Zimmerman

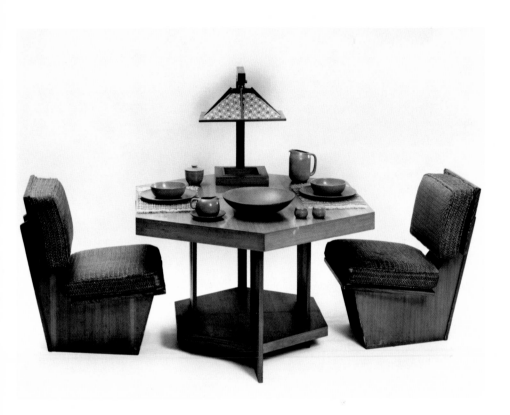

FRANK LLOYD WRIGHT (1867–1959),
American
Pair of Dining Chairs, c. 1950
Red cypress with covered foam seats, each,
29 x 18 x 24 (73.7 x 45.7 x 61.0)
Bequest of Isadore J. and Lucille Zimmerman
1988.7.24,.25

FRANK LLOYD WRIGHT (1867–1959),
American
Hexagonal Dining Table, c. 1950
Red cypress, 26 x 41½ x 48
(66.0 x 104.2 x 121.9)
Bequest of Isadore J. and Lucille Zimmerman
1988.7.27

FRANK LLOYD WRIGHT (1867–1959),
American
Table Lamp, c. 1950
Red cypress with block printed Japanese
paper shade, 21⅜ x 16¼ x 18½
(53.4 x 41.3 x 47.0)
Bequest of Isadore J. and Lucille Zimmerman
1988.7.30

ATTRIBUTED TO FRANK LLOYD WRIGHT
(1867–1959), American
Pair of Place Mats, c. 1952
Metallic thread, yarn, fibers, 18¾ x 11
(47.6 x 28.0)
Bequest of Isadore J. and Lucille Zimmerman
1988.7.87

HEATH COMPANY
Dining Service, c. 1955
Glazed stoneware
Bequest of Isadore J. and Lucille Zimmerman
1988.7.200–283 (set)

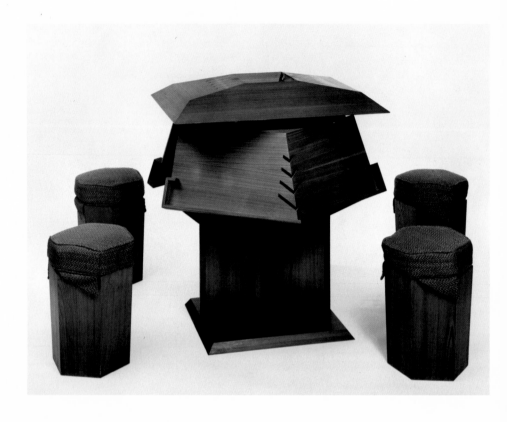

FRANK LLOYD WRIGHT (1867–1959),
American
Quartet Stand, c. 1950
Red cypress plywood, 41½ x 39 x 40
(105.4 x 99.1 x 101.6)
Bequest of Isadore J. and Lucille Zimmerman
1988.7.1

FRANK LLOYD WRIGHT (1867–1959),
American
Quartet Stand Stools, c. 1950
Red cypress with covered foam seat,
20 x 13¾ x 12 (49.8 x 34.9 x 30.4)
Bequest of Isadore J. and Lucille Zimmerman
1988.7.20–23

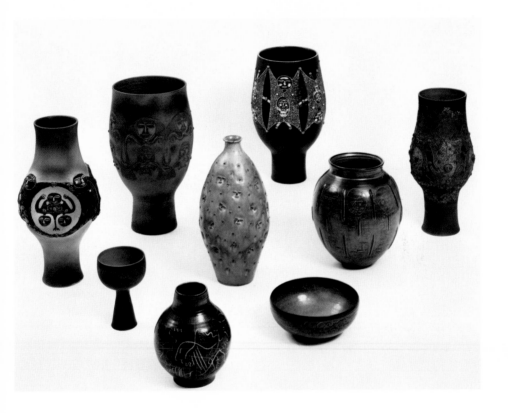

EDWIN SCHEIER (b. 1910), American
from left:
Vase
Glazed stoneware, 20¼ x 10 x 9
(51.4 x 25.4 x 22.9) 1988.7.175
Chalice
Glazed earthenware, 8⅜ x 5⅝ (21.3 x 14.3)
1988.7.116
Vase
Glazed stoneware, 20½ x 11¼ (52.0 x 28.5)
1988.7.148
Lamp Base
Glazed stoneware, 9⅞ x 8 (25.1 x 20.3)
1988.7.155
Lamp Base
Glazed stoneware, 18⅛ x 8½ (47.0 x 21.5)
1988.7.149

Vase
Glazed stoneware, 20⅛ x 11¼ (51.1 x 28.6)
1988.7.151
Bowl
Glazed stoneware, 4½ x 10¼ (11.5 x 26.0)
1988.7.139
Vase
Glazed earthenware, 13⅝ x 11 (34.5 x 27.9)
1988.7.150
Vase
Glazed stoneware, 19 x 10 (48.3 x 25.4)
1988.7.166
Bequest of Isadore J. and Lucille Zimmerman

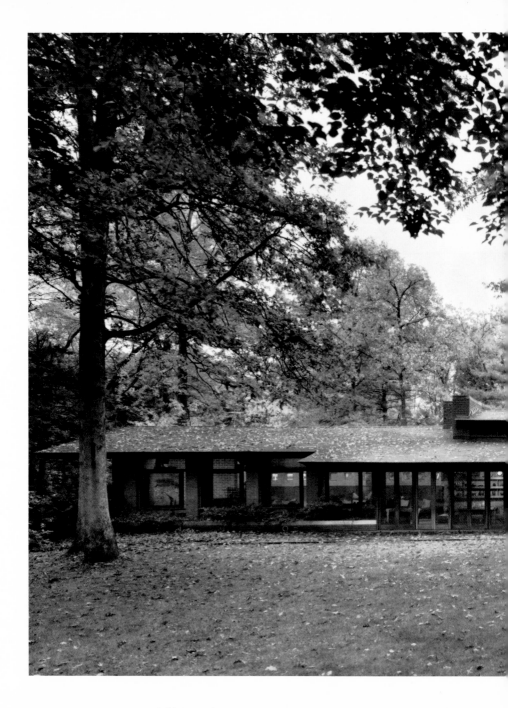

FRANK LLOYD WRIGHT (1867–1959),
American
Isadore J. and Lucille Zimmerman House,
1950
National Register of Historic Places, 1979
Exterior, view of south facade
Bequest of Isadore J. and Lucille Zimmerman

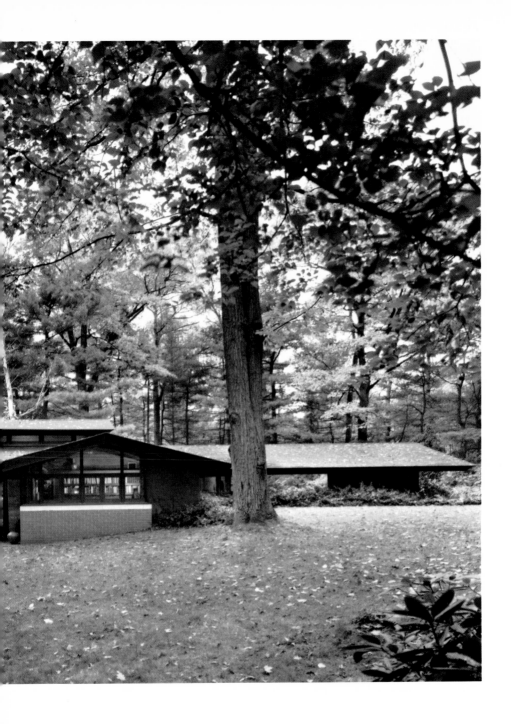